IMAGES
of America

ROYAL OAK

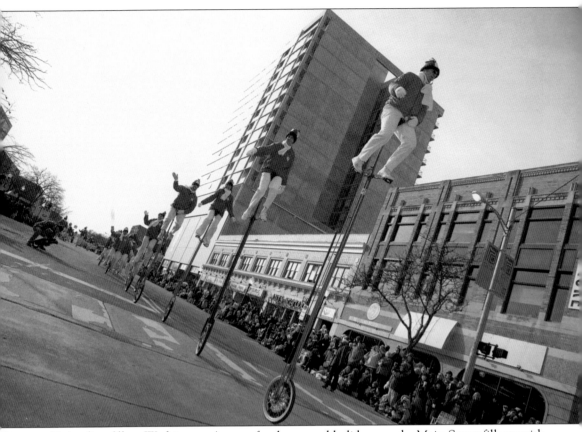

Unicyclists fill up Washington Avenue for the annual holiday parade. Main Street fills up with Harley-Davidson motorcycles on Wednesday nights, bringing a surge of business to the city. Hip entertainment is the hallmark of Royal Oak. The city offers a Memorial Day parade in the spring and a holiday parade in late fall, not to mention art festivals, gallery crawls, and other celebrations. Outsiders flock on summer nights to sip cocktails at sidewalk cafés or preen over their Harley Davidson and Honda motorbikes. Amid the gleeful clapping of children at parades and the stolen night kisses in front of the Star Dream Fountain, few know the story of Royal Oak, how this smart-sized downtown grew from gristmills to national prominence. (Courtesy Brad Ziegler Photography.)

ON THE COVER: Floyd J. Miller (left), publisher of the *Daily Tribune* and chair of the Royal Oak City of Trees committee, arranged in 1937 to have 50 acorns from the Royal Oak of England shipped to Michigan. In 1939, the seedlings were planted in prepared soil, mulched with oak leaves, then in 1949, moved to Memorial Park where many of the trees still grace this preserve. (Courtesy of the Walter P. Reuther archives.)

IMAGES
of America

ROYAL OAK

Maureen McDonald and John S. Schultz

ARCADIA
PUBLISHING

Published by Arcadia Publishing
Charleston SC, Chicago IL, Portsmouth NH, San Francisco CA

Printed in the United States of America

Library of Congress Control Number: 2009933635

For all general information contact Arcadia Publishing at:
Telephone 843-853-2070
Fax 843-853-0044
E-mail sales@arcadiapublishing.com
For customer service and orders:
Toll-Free 1-888-313-2665

Visit us on the Internet at www.arcadiapublishing.com

Maureen McDonald thanks her friends and family for their ongoing patience and encouragement. John Schultz thanks his wife, Debra, and daughters, Margaret and Hannah, for their enduring love and support.

CONTENTS

ACKNOWLEDGMENTS

Researching Royal Oak offered splendid opportunities to scarf down a burger at Mr. B's, sip a glass of chardonnay at the Town Tavern, or do penance with a quick-paced bike ride along Sherman Road to work off the calories. Maureen McDonald and John Schultz wish to give thanks to all the people that helped us get this book off the ground.

Special thanks to the Detroit Ink Slingers, the freelance writing group that helped encourage us to keep going and made suggestions for twisting phrases positively.

Particular thanks to former "Ink" member T. C. Cameron, author of Arcadia Publishing's *Metro Detroit's High School Football Rivalries* and second-generation resident of Royal Oak. We thank Michael W. R. Davis—multiple Arcadia book author—for mentorship; Anthony Ambrogio, Arcadia coauthor of *Cruisin' the Original Woodward*; and Cindy La Ferle, author of *Writing Home*.

Joe Ballor of the *Daily Tribune* helped find images and Jeff Payne, bless his soul, looked valiantly for original 8-by-10 photographs. Sara Martin and William Schenk at the Michigan Department of Transportation helped us find archival shots of I-696 from early protests to the smooth concrete on opening day. Les Ward of Les Ward Photography lent a hand with several historical photographs. Anne Maudlin helped us locate the fabled Dondero Wall of Fame, including four nationally known graduates, and Dave Krieger supplied pictures of Pronto!

Patricia Janeway, director of publicity for the Detroit Zoo, supplied its 75th anniversary book along with images and rich perspective.

Special thanks to Muriel and Frank Versagi, the directors of the Royal Oak Historical Society Museum, who opened up their archives for us to plunder and to Bill Roberts of the Roberts Restaurant Group, who generously reprinted images. Thanks to Owen A. Perkins for his valuable collection of historic Royal Oak photographs, and to Ralph Gustafson, owner of Mr. B's Restaurant Group, for great archival materials, and to Jack Hanna, founder of the Chrysos Development and Management Company, for a perspective on a modern city. Ruth Holmes of Pentec, Inc., in Bloomfield Hills facilitated a photograph of Jack Kevorkian. We thank Barry Shulman of Decades Royal Oak for use of the town's history books; Mary Wallace at the Walter Reuther Library for several images; and Grant Howell, longtime *Daily Tribune* editor, for teaching John and Maureen how to research fast and write well.

Unless otherwise noted, all images appear courtesy of the Royal Oak Historical Society.

INTRODUCTION

Raise a glass of thanks to Mary Ann Chappell, who was known as "Mother Handsome." This rough and boisterous character ran one of the first public houses in Royal Oak and helped create a sense of conviviality and welcome that has endured well over a century of progress.

According to the 1877 *History of Oakland County*, her wood-hewn inn was situated about 5 miles outside of Detroit, just off Saginaw Trail, a rutted stagecoach road maintained by a group of investors from a cow path and Native American trail. Mother Handsome was a beacon for immigrants and land-lookers in the 1820s and 1830s, before the railroad came through. Weary travelers heard the liquor was better and so was the food.

Travelers told of a cordon of tangled forests and dead morass north of Detroit. The legend still circulated about bloody battles between Native Americans in Pontiac and the French and British encampments near the Detroit River. Tribes coursing through Michigan included Wyandot, Potawatomi, Chippewa, and Ottawa. As the Native Americans receded from the lands, the settlers plundered dense forests to make their homesteads.

"As they [settlers from New York and the eastern states] cut their way into the Michigan wilderness they saw in the removal of the forests their future homes, log houses and barns, schoolhouses and churches, lumber for better dwellings and for marketing, tillable lands, and the comforts of life, and a competence," wrote James G. Matthews, city historian of Royal Oak, in a 1930 essay *Trees of Royal Oak: Their Part in History*.

"Much of the early timber was wantonly destroyed, being felled in a manner requiring the least amount of labor for burning it," Matthews wrote. Trees became planks for stagecoaches and rail beds for the fast-growing railroads navigating southeast Michigan.

By 1854, planks had been laid across the Saginaw Trail from Detroit to Pontiac. Infrastructure for rail lines improved steadily under a series of owners, including the Detroit and Milwaukee Railroad, making the area more attractive for settlers. Soon its residents were manufacturing cowbells and cultivating farms on the vast flatlands fed by the Red Run that flowed through what is now Vinsetta Boulevard in northern Royal Oak.

First the rail lines, then the roads brought settlers to Royal Oak, often called the "City of Trees," in Oakland County. We owe a large debt of gratitude to the visionary thinking of Horatio S. "Good Roads" Earle and Frank E. "Lift Michigan Out of the Mud" Rogers, according to Louis Mleczko in the 1995 anthology *The Technology Century*, published by the Engineering Society of Detroit.

These gentleman transformed roads made of dirt and the wood-plank horse trails of 1895—when only 60,000 miles of roads existed in all of Michigan—to the byways we take for granted. By 1903, with a modest budget of $20,000, the early roads became graded enough for the new horseless carriages to rumble across the land. Saginaw Road soon became Woodward Avenue, after the famous Judge Augustus Woodward.

Industrialization replaced agriculture as the viable source of employment. The automobile economy zoomed forward. People came from all over the world to gain lucrative paying, assembly line jobs.

Thanks to automobile manufacturing and soaring sales, Metro Detroit jumped from 13th to fourth place in population between 1900 and 1920. Single-family bungalow dwellers in Royal Oak worked for Oakland automobiles in Pontiac, for Ford Motor Company and Maxwell in Highland Park, and the Dodge Brothers in Hamtramck. Transportation was easy along two streetcars and two passenger rail lines serving Royal Oak. As wages rose, so too did the car-driving population.

Royal Oak became a village in 1891. By the beginning of the 20th century, it was a full-fledged town. Among its attributes were the *Royal Oak Tribune* (1902), electric light plant (1903), and the Royal Oak Savings Bank (1907). Soon culture and safety were added. The Idle Hour moving picture house (1910) and a volunteer fire department arrived in 1913, according to Arthur A. Hagman, editor of the 1970 *Oakland County Book of History*. By 1921, Royal Oak was a full-fledged, incorporated city installing George A. Dondero as mayor.

The location became magnetic for home seekers. Royal Oak's population increased nearly four-fold during the 1920s, rising from 6,000 in 1920 to 22,904 in 1930. This boom helped build wealthy mansions on Henrie Avenue and country estates along the Red Run and Vinsetta Boulevard. Autoworkers settled in small bungalows close to the streetcar lines. Magnificent churches and schools rose to meet the needs of the multidimensional community.

Horse travel diminished as roads became smoother and cars more comfortable. Soon the entire standard of living hiked up, along with ladies' skirt lengths and closed-coupe autos. The Red Run—once a surging stream for a lumber mill—became a giant drain big enough to ride an automobile through it. Steel waterlines were constructed in 1925 to bring Detroit water to the town, and by 1927, the city boasted the largest telephone exchange in south Oakland County.

Hagman's demographic research found that before 1904, Pontiac, Bloomfield, and Avon (Rochester Hills) were the most populous of the nine southeastern townships. Royal Oak leapfrogged above them, holding a third of the county's residents until 1930, when the Great Depression brought a temporary halt to expansion.

Royal Oak's population surged in the 1950s and 1960s owing to generous government mortgages for World War II and Korean War veterans. The town reached the peak population of 100,000 in the 1960s and dropped precipitously the next decade to 60,000, as a new breed of settlers pressed farther into the open suburbs. Here they bulldozed verdant apple, peach, and horse farms to occupy giant tract subdivisions with bigger lots and wider garages.

The city became the epicenter of youthful frolicking in the 1960s. American automobile manufacturers brought out a whole complement of cruising cars for the footloose baby boomers—Ford Mustangs, Dodge Barracudas, and Chevy Camaros—and they roared up the Woodward Avenue. The collective car lovers in the 1990s and 21st century deified the street as the cruising capital of America. The next group of young Generation Xers revived the Royal Oak downtown, rebuilt the Baldwin Theater for the Stagecrafters live theater, and patronized a new category of coffee shops and outdoor cafés.

Into the 21st century, all roads converge on Royal Oak for many reasons. Automobile enthusiasts of all ages reclaim their youth when the grassy, eight-lane boulevard of Woodward Avenue becomes a cruising lane for one glorious week in August, drawing more than one million car revelers from around the country. Throughout the year, pedestrian roads or sidewalks throng with people, sidewalk cafes, shops, taverns, and movie theaters. Main Street bustles with commuters and commerce even as it bucks the lingering economic recession. The smooth-surfaced I-75 and I-696 expressways shuttle motorists of all ages to events and activities in Royal Oak. An intermodal transportation center near downtown brings people by taxi, train, or bus.

Once here, you will find it is a city of 11.8 square miles, 7.6 million acres, a veritable City of Trees, thanks to aggressive tree plantings.

Grab a cup of coffee or a beer. Stop awhile at a park bench under a tree. Come learn about Royal Oak from two reporters who have written about the town for most of their adult lives and have chronicled its progress since the 1970s. Ours is a story of deep roots in a cozy-size downtown and a picture history of how people fill it with personality and pride.

One

Swamp Oaks and

Trading Posts
1880s to 1900

Meticulous records bound in leather volumes, handwritten shards of yellowed paper, and rare photographs chronicle the migration of settlers to marshy lands filled with swamp oaks. A surveyor to the governor of the Michigan Territory told Lewis Cass the land was incapable of cultivation. After his visit, the wagons began hauling pioneers and the steam engines followed.

The earliest settlers—largely on Thirteen Mile and Crooks Roads—struggled mightily to claim a place in the history books and earn enough dollars to keep their families alive with roofs overhead. Hardy people endured the Panic of 1819, a depression that occurred over too-rapid, too-costly land sales at $2 an acre. Then came the War of 1812 that claimed young farmers and decimated their families.

Yet the promise of wide-open land was especially enticing to New Yorkers and Pennsylvanians. The Erie Canal opened the Midwest, a 363-mile waterway that drastically cut shipping costs. "The Canal's impact over the first five years was not that spectacular, but after 1830, thousands of settlers invaded Michigan's Lower Peninsula via this waterway," writes Arthur Hagman in the 1970 *Oakland County Book of History*.

Sherman Stevens, the railroad entrepreneur, laid out the little village and railway station in 1836. By 1876, the area had railroad company buildings, a steam sawmill, three blacksmith shops, one hotel, three general stores, one millinery store, two drugstores, two physicians, four churches, a town hall, and the handsome schoolhouse of District No. 6. Its first newspaper was the *Royal Oak Experimental* in 1876, according to the 1977 *History of Oakland County*. The village was incorporated in 1891 by a decree of then governor Edwin B. Winans. Charles Allen, deemed the "father of Royal Oak," circulated petitions and championed the vision that endured long after his death in 1934.

Here is how a town was born.

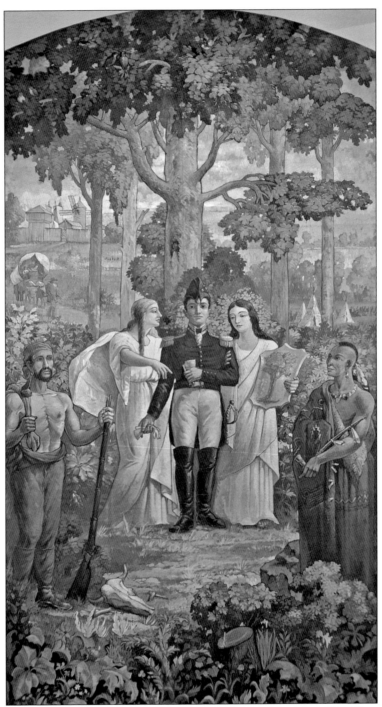

In ancient legends, Siddhartha Gautama, spiritual teacher and founder of Buddhism, achieved enlightenment while sitting under a bodhi tree with heart-shaped leaves. This 1930s drawing, which hangs in the Royal Oak Middle School, depicts territorial governor Lewis Cass, in 1819, standing under what he proclaimed was a "Royal Oak." The goddesses come from heaven to bless his discovery. Soldiers and Native Americans celebrate. (Photograph by Trista Sample.)

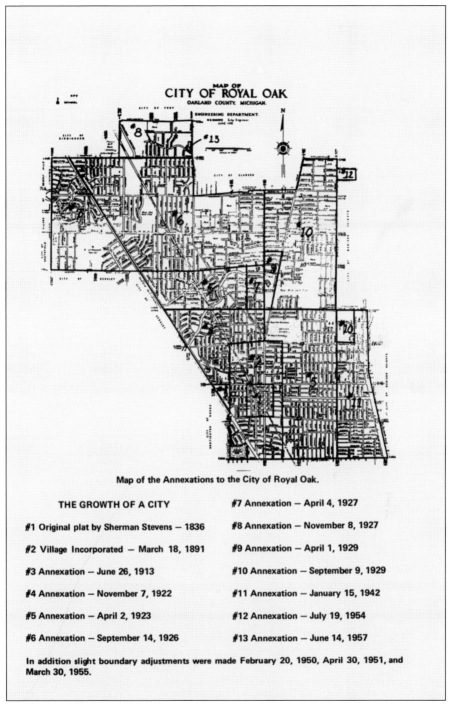

MAP OF
CITY OF ROYAL OAK
OAKLAND COUNTY, MICHIGAN.
ENGINEERING DEPARTMENT.

Map of the Annexations to the City of Royal Oak.

THE GROWTH OF A CITY	
#1 Original plat by Sherman Stevens — 1836	#7 Annexation — April 4, 1927
#2 Village Incorporated — March 18, 1891	#8 Annexation — November 8, 1927
#3 Annexation — June 26, 1913	#9 Annexation — April 1, 1929
#4 Annexation — November 7, 1922	#10 Annexation — September 9, 1929
#5 Annexation — April 2, 1923	#11 Annexation — January 15, 1942
#6 Annexation — September 14, 1926	#12 Annexation — July 19, 1954
	#13 Annexation — June 14, 1957

In addition slight boundary adjustments were made February 20, 1950, April 30, 1951, and March 30, 1955.

A map of Royal Oak shows the village boundaries and numerous annexations. Royal Oak was initially inside Troy township and later became Royal Oak township, including a wide swath of land from approximately 14 miles on the north side and Eight Mile Road on the south side. Travel was principally found on the Saginaw Indian trail, running from Pontiac to downtown Detroit on plank roads. (Courtesy of the Owen A. Perkins collection.)

John Benjamin Jr. (below), a school assessor, then Royal Oak township treasurer from 1876 to 1880 and also a constable, succeeded his father, who made his fortune on Benjamin grain cradles known all over the Midwest, according to *A Portrait and Biographical Album, Oakland County, 1891*. He had a 160-acre farm at Woodward Avenue and Twelve Mile Road and an added fortune from selling a portion of his property as a railroad right-of-way.

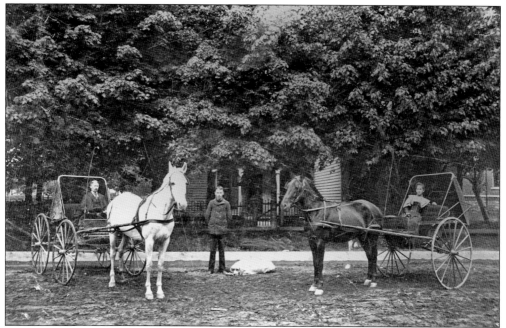

Doctor and Mrs. (first names unknown) Kidder (opposite carriages) traveled out to meet Will Roby (center) in the late 1800s from their home at Fourth and Main Streets. Royal Oak became a village in 1891 by decree of then governor Edwin G. Winans. Travel to and from Detroit and Pontiac was progressively easier but still precarious on rutted roads and cow paths.

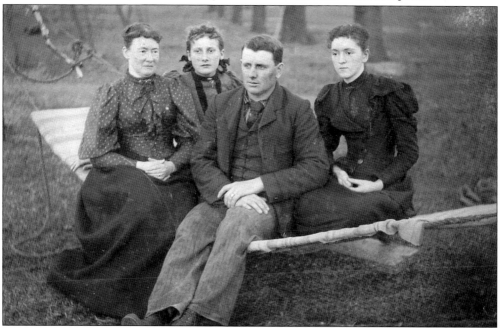

Lee Blodgett is pictured with his mother and sisters in this late 1800s photograph. According to Muriel Versagi of the Royal Oak Historical Society, the sisters married into the Parker clan and became third- and fourth-generation Royal Oakers. Their kinder donated their farm property to make way for the William Beaumont Hospital at Thirteen Mile Road and Woodward Avenue.

Migrating from western New York State, Orson Starr purchased an 80-acre tract of land in Royal Oak in 1831 and raised his 10 children first in a log cabin near Thirteen Mile and Rochester Roads, and then in a palatial house near Main and Lawrence Streets that stands today as a museum. Satisfied customers said his cowbells—manufactured in Royal Oak—could be heard tinkling for 2 miles. (Courtesy of the Owen A. Perkins collection.)

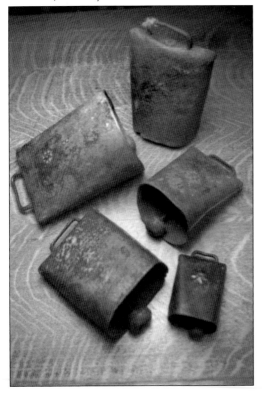

Starr's cowbells drew a national following among westward-bound pioneers and farmers according to historian Owen Perkins. For 40 years, the company produced eight sizes of bells made of iron, copper, and zinc. The quality of the bells was due to the brazing process, where the clay from Royal Oak was finely ground in a mill and mixed with manure to prevent disintegration in the furnace. (Courtesy of Les Ward Photography.)

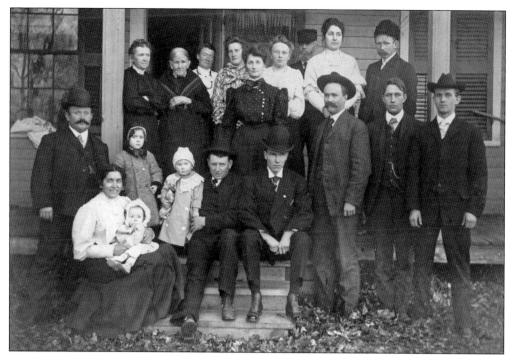

A gathering of the Benjamin clan depicts one of the pioneering families as they strengthened in numbers. John Benjamin came in 1830 and began making grain cradles for farms all over the Midwest. The longtime local family donated its entire album to the Royal Oak Historical Society.

The Benjamin house, built in the 1854, served first as a residence, then as an antiques house, then as a restaurant, and was torn down in 1968. According to historian Clara E. Kidder, a part of the family farm at Twelve Mile Road and Woodward Avenue became the popular Aunt Fanny's restaurant in the 1960s, then incorporated into the Roseland Park Cemetery.

A wealthy family like the Hawkins, featured here, might have sold land to newcomers or lumber to burgeoning industries, or worked for the railroads that rapidly bisected the region.

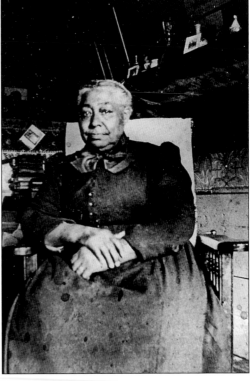

Gilbert and Elizabeth Hamer escaped slavery in Covington, Kentucky, followed the Underground Railroad north, and wound up in Royal Oak in the 1850s, where Orson Starr gave Gilbert work. Elizabeth (pictured here) raised their six children, ducks, geese, and guinea hens. Eventually they bought 7 acres of property near Crooks Road and Webster Street, which remained in the family until the 1960s. (Courtesy of the Owen A. Perkins collection.)

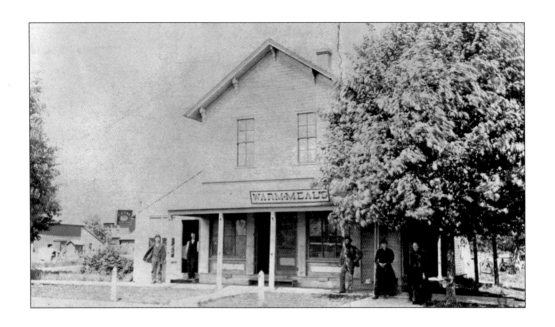

Commerce came to Royal Oak by stagecoach and train. Pictured in the photograph above is a small trading post for the village of 400 at the northeast corner of Fourth and Main Streets. Below is the Half Way House, a travel stop along the Saginaw Trail near the present location of the Detroit Zoo, run by one of the Benjamin family members.

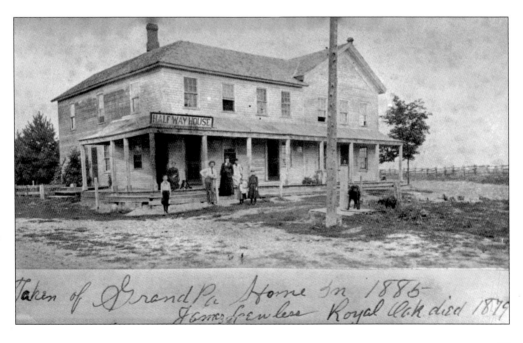

Taken of GrandPa Home in 1885
James Grewless Royal Oak died 1879

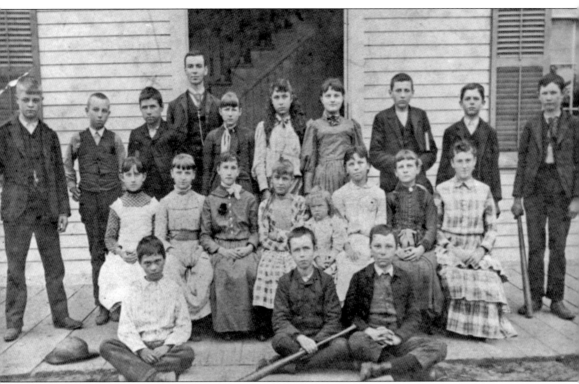

This 1893 schoolhouse—full of smiling and mischievous children of a farming society—stood at Main Street and Lincoln Avenue. The teacher was Eugene Snowden. Note the baseball bats in hands of several of the boys.

Two

SEEDS OF PROGRESS
1900 TO 1930

Detroit, and its surrounding suburbs, was destined to put the nation on wheels owing to its relation geographically to Canada and the eastern United States. Its versatile manufacturing economy—including bricks, plows, and cowbells in Royal Oak; stoves and railcars in Detroit; and carriages in Flint and Pontiac—set the stage for automotive manufacturing at the dawn of the 20th century.

Historian Melvin G. Holli says that on the eve of the manufacturing "takeoff" in 1904, the foreign-born constituted one-third of Detroit's population, and among them were 13,000 Poles, 1,300 Russians, and 904 Italians. The 1910 foreign-born population of 156,365 doubled to 289,297 in 1920. By 1925, the foreign-born constituted about one-half of Detroit's 1,242,044 people, the Poles leading the list with 115,069. Italians then numbered 42,457, Russians 49,427, and from almost a zero baseline, Hungarians had come to number 21,656, according to Holli in his book, *Detroit—the Documentary History of an American City.*

The population explosion that led to numerous townships like Royal Oak incorporating as cities and interurban streetcar lines supplying labor to the automobile plants, helped Detroit jump from 13th to fourth place in population among major American cities between 1900 and 1920. The impact of migration disrupted Detroit's social patterns, stretched its boundaries, crowded its housing, and created new sanitary, health, and education crises. And yet it brought fabulous wealth to automotive and real estate investors, particularly those who developed Henrie Avenue and Vinsetta Boulevard as early subdivisions for the barons of new industry. Worker cottages and bungalows sprung up along streetcar lines.

Horses began to disappear from city streets and farm fields. Then streetcars vanished to make way for more automobiles. Then the Red Run itself became part of the Twelve Towns drain. Four motion picture movie houses sprouted downtown. Retail flourished. Royal Oak offered the admirable feature of being a complete town with a host of services and yet connected to the larger city and region through varied transportation lines. With a mix of schools and churches, it became a leading suburb.

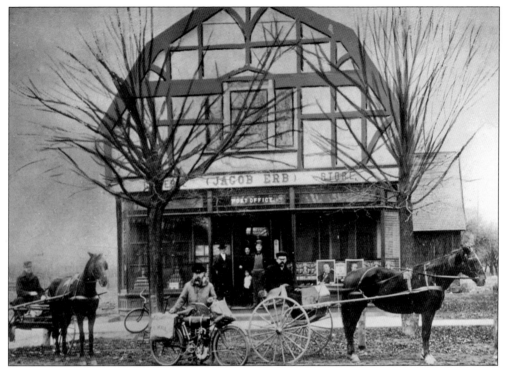

Jacob Erb ran a general store and post office at the southeast corner of Main and Second Streets in 1908. Here the pony express stands at the ready to deliver mail, augmented by bicycle. (Courtesy of the Owen A. Perkins collection.)

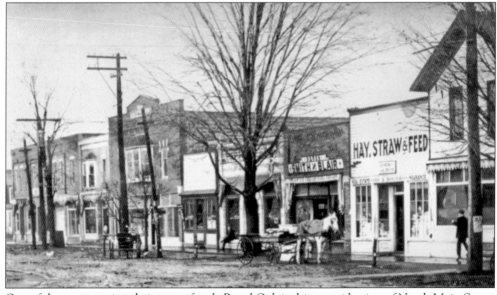

One of the most reprinted pictures of early Royal Oak is this east side view of North Main Street between Third and Fourth Streets in 1907. A grocery on the block, constructed by Gus Dondero, became Hermann's Bakery and remains one of the few original buildings still in existence, sending the delectable aroma of sugared confections and bread throughout the community. (Courtesy of the Owen A. Perkins collection.)

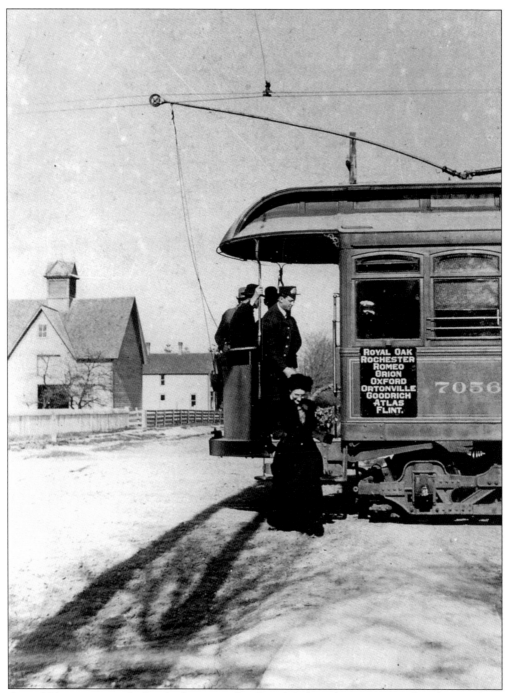

Anna Hilzinger, part of a family that arrived in Royal Oak in the 1860s, travels to her teaching job in Troy along the Rochester interurban that ran from downtown Royal Oak to Rochester to Goodrich and up to Flint in 1904. Part of the town's success in this decade came from its access to multiple streetcar, train, and carriage routes. (Courtesy of the Owen A. Perkins collection.)

In 1913, a bustling Woodward Avenue included telephone lines, a Grand Trunk rail line, and a narrow road for those sputtering, backfiring automobiles. Many people still traveled by horse and carriage, but not for long. Within the next couple decades, the road would be widened to eight lanes of groomed concrete and asphalt. The train track would be rerouted several blocks east.

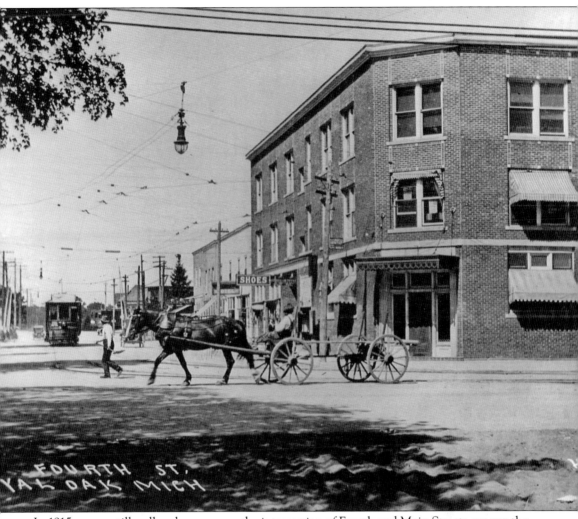

In 1915, a man still walks a horse across the intersection of Fourth and Main Streets, among the last years the horse had any right-of-way. This ditty by Grace Duffied Goodwin speaks to his gait: "I have a humble longing that has never been confessed, a longing I have striven in vain to bury in my breast; I want to take a ride once more, when the days are hot and muggy, behind a little jogging horse in some old shabby buggy." The building was one time home to the Royal Oak Library.

This is a stretch of Twelve Mile Road looking east from Woodward Avenue around the early 1900s. The one-lane road is nothing more than wood planks laid down to keep carriages and early cars from getting stuck in the mud.

The first electric substation at the southeast corner of Main and Seventh Streets, which powered the streetcars, illuminated progress. It became Billing's Feed Supply and was renovated in 2007 to become the Cloverleaf Wine in its cellar and offices of Michael Chetcuti's Streetcar USA upstairs. Billings moved to a site north of Eleven Mile Road. (Courtesy of the Owen A. Perkins collection.)

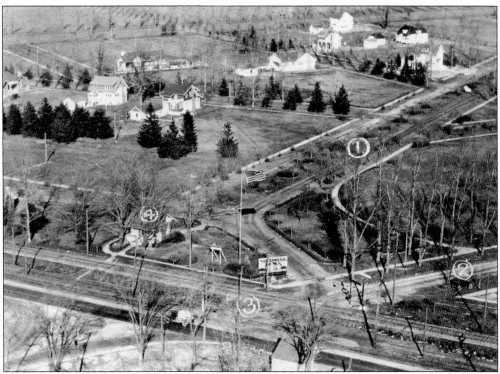

In 1920, the ground was platted for a future Northwood subdivision. Therese Clawson Christman, granddaughter of the developer F. W. Clawson said he bought 132 acres, then another 156 acres, and promoted it far and wide. The family sold the land on the corner to Fr. Charles Coughlin for the Shrine of the Little Flower and donated their farmhouse to the First Congregational Church of Royal Oak for its current chapel. Early residents campaigned for a fire station to serve the new homes and older farms. When it was decommissioned, it was donated to the Royal Oak Historical Society for its museum.

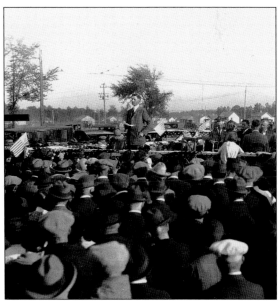

Standing tall, much like his idol Abraham Lincoln, George A. Dondero addresses a crowd of thousands that gathered on September 27, 1924, for the opening of a portion of Stephenson Highway, among the first multilane "super highways." It was named for Burnette Fechet Stephenson, a real estate magnate, who in 1916 paid $1.5 million for 1,800 acres of farmland east of Woodward Avenue between Highland Park and Royal Oak. According to an article by the Michigan Department of Transportation, within that tract, he plated more than a dozen subdivisions and opened more than 5,000 home sites in south Oakland County. (Photograph courtesy of Royal Oak Library.)

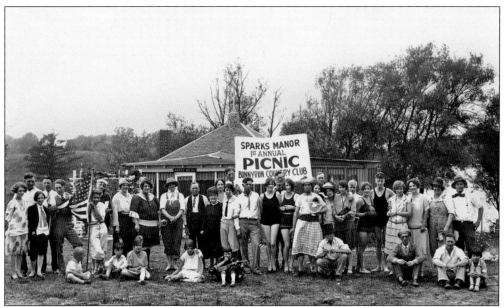

A Sparks Manor picnic drew the town faithful outside. The sponsor was Jacob B. Sparks, entrepreneur, city commissioner, founder of WEXL Christian Radio, and author of *Jacob's Well of Life: New Sparks from Old Time Religion, the Autobiography of Jacob B. Sparks.*

The first attempt to rein in the Red Run and reduce flooding occurred in 1925 when Oakland County—on the north end of town—built the Royal Oak drain big enough to house Arthur C. Spencer, Oakland County drain commissioner, and the contract supervisor in a full-sized automobile. The vehicle was lowered into the drain to show the scope of the project. Payment for the job came from an ad valorem tax on property.

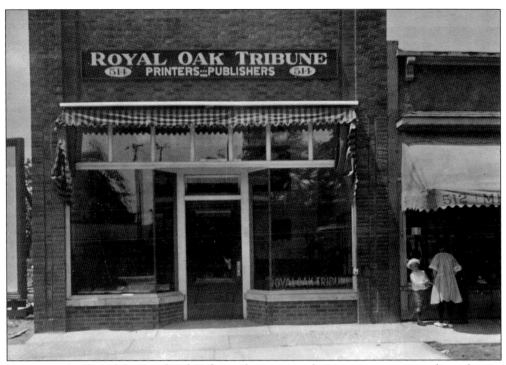

The original office of the *Royal Oak Tribune*, the town's enduring newspaper, was a bungalow on West Fifth Street, started in 1919 as a weekly publication. It flourished under the leadership of Floyd J. Miller, the former reference director at the *Detroit News*. In 1922, the company constructed its own building on South Washington Avenue (pictured here) and became a daily paper covering Berkley, Clawson, and Hazel Park, as well as Royal Oak. Today it is published out of Mount Clemens, sharing office space with the *Macomb Daily*, once its biggest rival for regional news.

One of Royal Oak's first newspapers was the *Royal Oak Midget* in 1879 that helped establish a community among the farmers. (Courtesy of Royal Oak Public Library.)

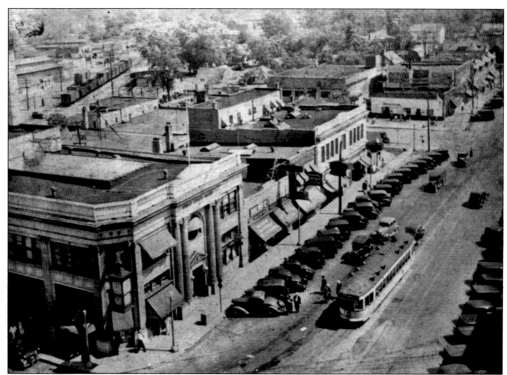

The First State Bank of Royal Oak occupied the southeast corner of Washington Avenue and Fourth Street in 1920. It consolidated in 1931 with the Royal Oak State Trust and Savings Bank, but the merged bank was shuttered during the bank holiday six months later.

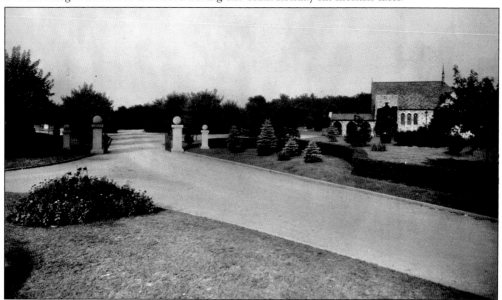

Oakview Cemetery occupies a pie-shaped piece of land at the intersection of Crooks Road, Main Street, and Rochester Road. Its first 6 acres were acquired in 1826 and in 1857, it was purchased for burials by the City of Royal Oak. The majestic entrance was added in the 1920s, and the most recent addition is a Holocaust memorial sculpture.

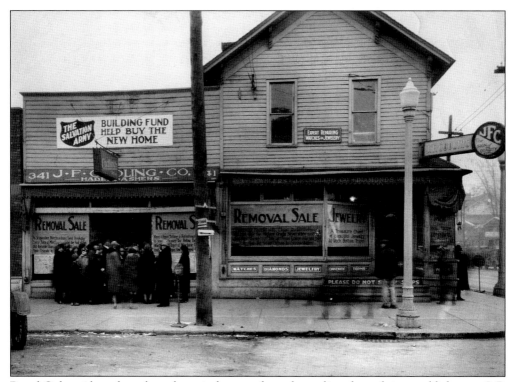

Royal Oak residents have been bargain hunters from the earliest days of city establishment. J. P. Codling was one of the finer haberdashers and jewelers, with a store at Main and Fourth Streets in the 1920s.

Some of Royal Oak's affluent residents gathered round a men's store to show off their finery in this 1920s photograph. Hats were a hit in men's fashion until Pres. John F. Kennedy assumed office in the 1960s, and automobiles took a lower, streamlined profile.

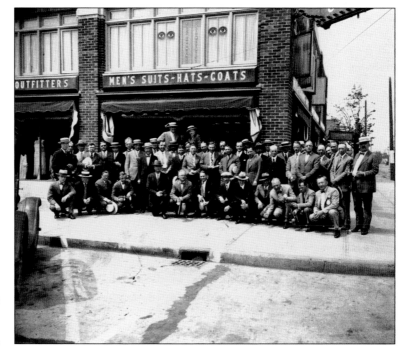

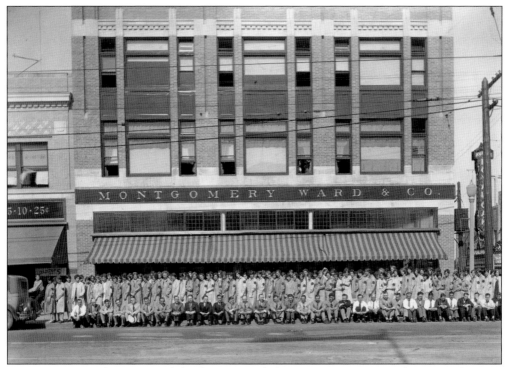

Montgomery Ward's was one of the first national chain stores to occupy a large storefront on Washington Avenue. In 1929, the chain had over 500 stores around the country, including Royal Oak. Such a momentous boost to the economy and convenient retailing, Ward's store featured its entire employee group outside the building. Stores today would have four times as much merchandize and not even one-quarter the helpers waiting on customers.

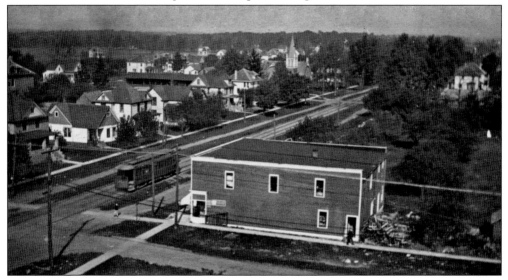

A bird's-eye view of Washington Street and Lincoln Avenue in the 1920s shows a store and residence on the spot now occupied by the entrance to Oakland Community College. Running down on Washington Street is the interurban streetcar. Many of the homes are still occupied and impeccably maintained.

Three

VITAMIN Z
THE DETROIT ZOO EXPERIENCE

"No Zoological park is ever completed. There is always a novel specimen, or a new method of display. It is an educational work that is always undone, and therein lies a large part of its fascination," said Henry Ledyard, president of the Detroit Zoological Commission at the park's dedication ceremony on July 31, 1928.

According to the book, *Wonders Among Us, Celebrating 75 Years of the Detroit Zoo*, the Detroit Zoological Park was the first in the United States to showcase its animals without bars, instead using moats, rocks, and shrubbery and discreet fencing to replace locked cages. But a polar bear staged a brief escape the first day, convincing officials to dig a deeper moat.

Over the years, the zoo became popular to animal entertainment acts, including a Cognac-drinking chimpanzee and dancing elephants. Then times shifted and the welfare of animals moved center stage. Polar bears gained a wonderful setting called the "Arctic Ring of Life," an exhibition that helped explain global warming; the chimps received an African setting that echoed the research of famous anthropologist Jane Goodall. Its magnificent dancing bear fountain had a magical role in the 2009 children's movie *Coraline*.

The Detroit Zoo houses 1,636 animals of 259 species (excluding invertebrates). To be sure, zoo tourists add about $60 to $80 million to the local economy. Over 1.2 million visitors annually descend on the zoo for what it calls "Vitamin Z," communing with the animals and nature in a world-class environment.

Well over 10,000 visitors arrived by streetcar and motorcar to see the new Detroit Zoo on Woodward Avenue and Ten Mile Road in the first month. The book, *Wonders Among Us*, said a zoo tractor pulled out 100 cars from muddy, vacant lots nearby on the first day in 1928. Visitors saw polar bears, black and brown bears, lions, wapiti elks, ostriches, wolverines, raccoons, eland antelopes, zebras, blue gnus, moose, mule deer, blesboks, Kaffir buffalo, and aoudads. And it was only half complete. (Courtesy of Detroit Zoo archives.)

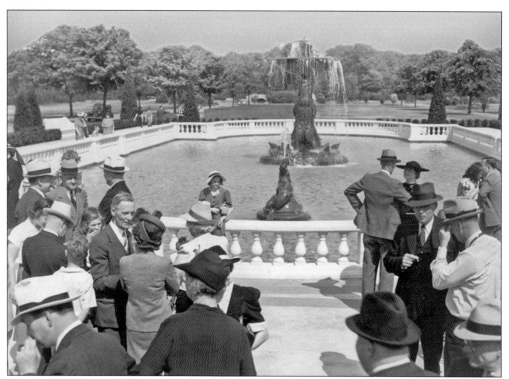

The Rackham Memorial Fountain was dedicated on June 3, 1939, honoring Horace Rackham, the first president of the Zoological Commission. The bronze bears stand 10 feet tall, gushing water. (Courtesy of Detroit Zoo archives.)

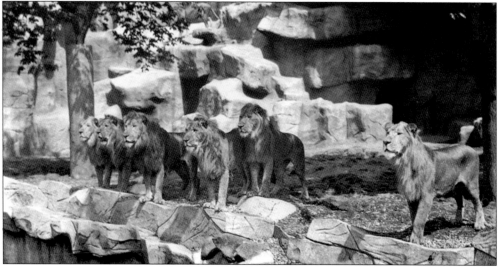

This starring historical moment featured lions named after zoo commissioners in 1932, including Henry Ledyard, Walter O. Briggs, James S. Holden, and Gilbert E. Miller. All 19 lions lived in this exhibit, adapting well to captivity. The zoo land was once a large swamp purchased by the City of Detroit by then mayor John C. Lodge, ostensibly to display bison and pheasants. About half of its 125 acres are in Royal Oak and the other half in Huntington Woods. (Courtesy of Detroit Zoo archives.)

With box cameras at the ready, children attending the Detroit Zoo season opener in May 1938 capture pictures of the animals, a timeless pursuit for tourists. (Courtesy of Detroit Zoo archives.)

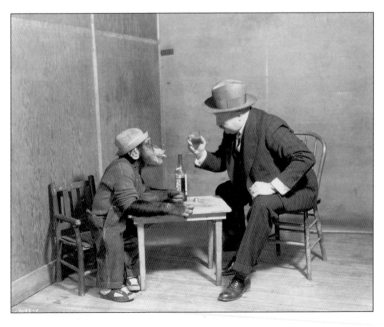

Theatrics of the 1930s included Detroit Zoo director John Millen feeding alcohol to a chimpanzee named Jo Mendi. He was the star of the chimp shows, but behind the scenes, he was described as a boisterous, raucous, difficult-to-control, wild animal. The director was said to carry a $40,000 liability policy on the cognac drinking, cigar-chomping chimp. (Courtesy of Detroit Zoo archives.)

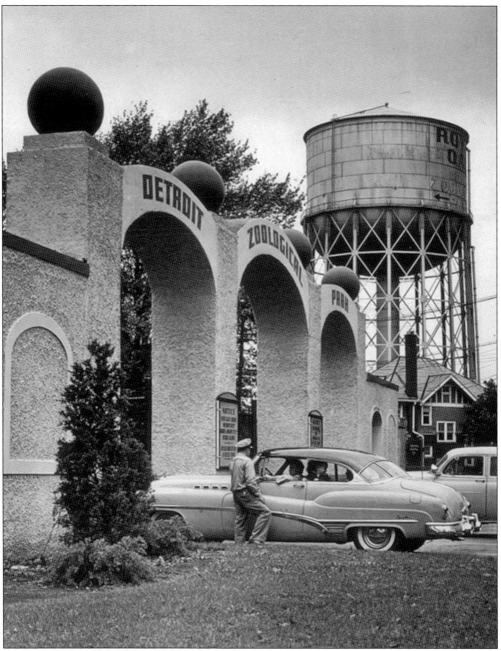

The Detroit Zoo entrance gate in the 1950s was flanked by off-premises restaurants—such as Hedges Wig Wam and the Dipsey Doodle—and a gaggle of souvenir stands selling Davy Crockett raccoon-tailed caps. Inside the zoo, visitors gravitated to a chimp show in an amphitheater setting and a concession stand that sold creamsicles and soda pop. (Courtesy of Detroit Zoo archives.)

This 1948 image depicts the unique rock formations that made exhibits at the Detroit Zoo so idyllic for visitors. Other zoos had thick bars that looked like circus wagons in a traveling show. (Courtesy of the Walter P. Reuther archives.)

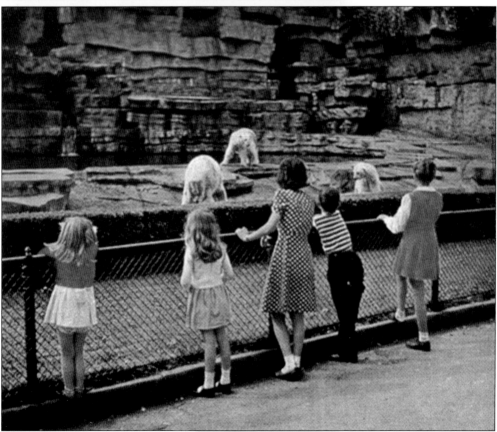

Polar bears are among the most popular animals in the zoo and in fictional lore. In 1947, a photographer from *Holiday Magazine* captured children watching the exhibit. The exhibit was extensively remodeled as the Arctic Ring of Life. (Courtesy of Detroit Zoo archives.)

Zoo director Steve Graham, in late 1989, ended the popular chimp shows and took costumes off the primates to honor their natural habits with the zoo's mission to celebrate and save wildlife. With the help of environmentalist Jane Goodall, he led fund-raising to build an $8.5-million, 4-acre Chimps of Harambee exhibit with hills, trees, and one-way viewing glass. (Courtesy of Detroit Zoo archives.)

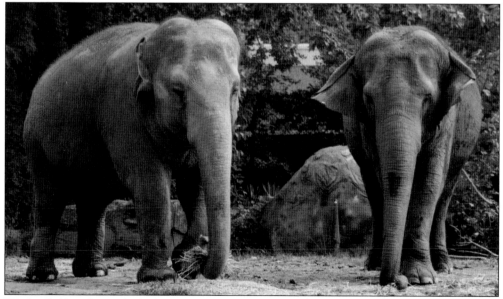

Winky (left) and Wanda (right) were shipped to an elephant sanctuary in 2005 amid a flurry of controversy in the daily newspapers. Detroit Zoo director Ron Kagan closed their exhibit because both animals—51 and 46—suffered from arthritis, and he sought better treatment for their golden years. Captured in the wild in their youth, they were shipped to a natural habitat outside Los Angeles with hundreds of acres to roam. (Courtesy of Detroit Zoo archives.)

After the I-696 construction, the entrance gate to the Detroit Zoo was reconstructed and a parking ramp installed for visitors. This $12 million enhancement with state and federal funding afforded the construction of a three-story, 600-car parking garage and a wide staging area for the numerous walks for charity and health on the premises. (Courtesy of Detroit Zoo archives.)

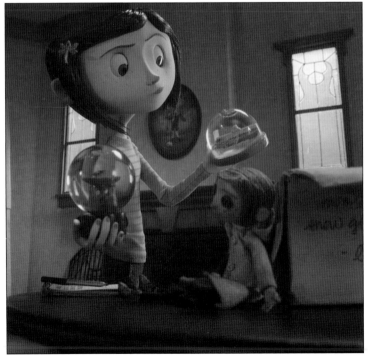

The dancing bears of the Detroit Zoo's Rackham Fountain gained worldwide attention when they were replicated in the magical snow globe the heroine played with in the 2009 children's movie *Coraline*. (Copyright 2008 LAIKA, Inc. All rights reserved.)

Four

SOWING SPIRITUALITY
CHURCHES AND WORSHIP

Churches began sprouting up in the mid-1830s, helping congeal the faithful in a spiritual community. As early as 1836, Catholic masses were shared in Royal Oak farmhouses.

Soon after, other parishes began building across the then Royal Oak Township, including the First Baptist Church, First United Methodist Church, and First Congregational Church.

If churches helped sustain families, one pastor put the town on the map nationally with vitriolic sermons. His church became a pilgrimage for the faithful, while roadside motels and restaurants along Woodward Avenue sprang up to accommodate the masses.

In early 1925, the Archdiocese of Detroit assigned a young priest, Charles E. Coughlin, to establish a parish to meet the growing needs of south Oakland County. Strapped for cash to build a suitable church, he took to the airwaves on clear channel WJR radio.

Within a few years, Father Coughlin's message turned to politics, and his ultraconservative views became a major power in the U.S. far-right-wing movement in the Great Depression. At the height of his popularity, the "Radio Priest" had one-third of the nation—about 30 million—tuned into his weekly broadcasts. In the early 1930s, Coughlin was arguably one of the most controversial men in America.

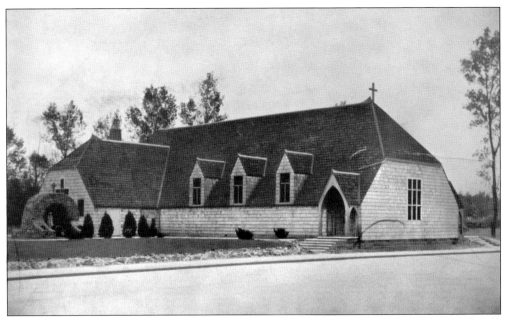

Hero and demagogue Fr. Charles E. Coughlin was directed to establish a new parish in Royal Oak, an area north of the city where growth looked promising. With no money and the archdiocese as a cosigner, he found some land around Twelve Mile Road and Woodward Avenue and bought it. Construction of the original wooden church started in May 1926 at the cost of $100,000, with the ability to seat 600. To help pay for the church, Father Coughlin began broadcasting a program aimed at children on WJR. (Courtesy of National Shrine of the Little Flower.)

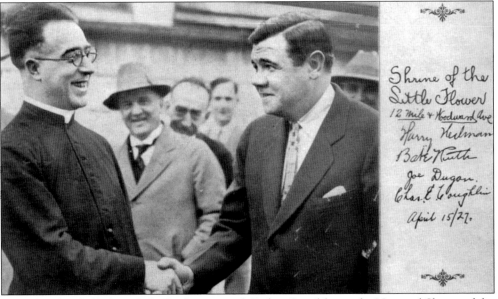

Legendary baseball player Babe Ruth visits with Father Coughlin at the National Shrine of the Little Flower April 15, 1927. It was said that "The Babe" told parishioners that morning that he did not want to hear coins hitting the collection plate, referring to only cash being offered. That year, Ruth set a record hitting 60 home runs for the season. (Courtesy of National Shrine of the Little Flower.)

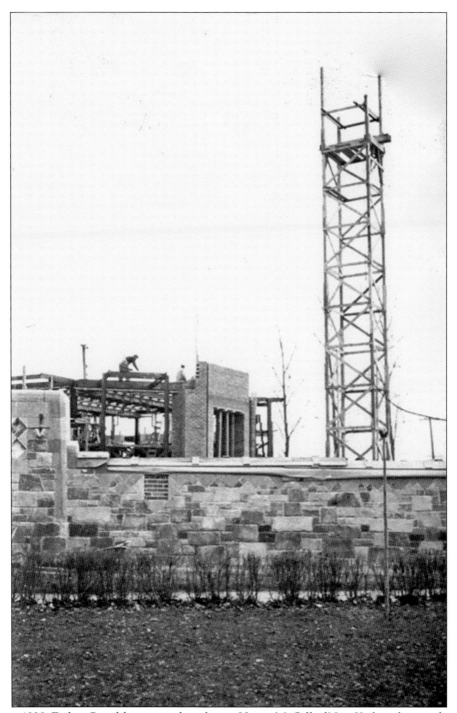

Late in 1928, Father Coughlin met with architect Henry McGill of New York to discuss plans for the construction of an expanded church. The Shrine's dramatic limestone art deco tower called the Charity Crucifixion Tower, which was built first and completed in 1931, includes a large figure of Christ on the cross, 28 feet high. The tower stands 104 feet, and Coughlin's study and broadcasting station were on the sixth floor. (Courtesy of National Shrine of the Little Flower.)

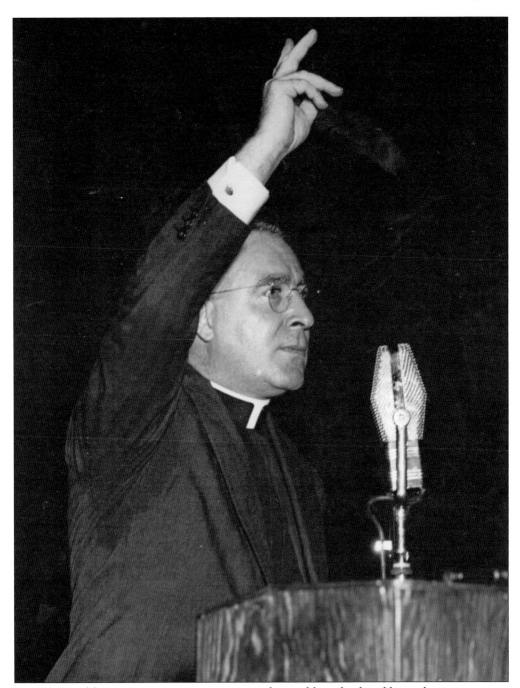

By 1930, Coughlin's reputation as an orator grew as his weekly and radio addresses began to espouse compassionate capitalism—a popular sentiment as the nation fell into the Great Depression. Eventually 30 million people heard the broadcasts nationally. Known as the "Radio Priest," Coughlin became a political force, attacking "godless communism," the New Deal, labor unions, and the international banking community. Increasingly his combative rhetoric drew critics, his audience shrank, and his superiors ended his radio career. (Courtesy of National Shrine of the Little Flower.)

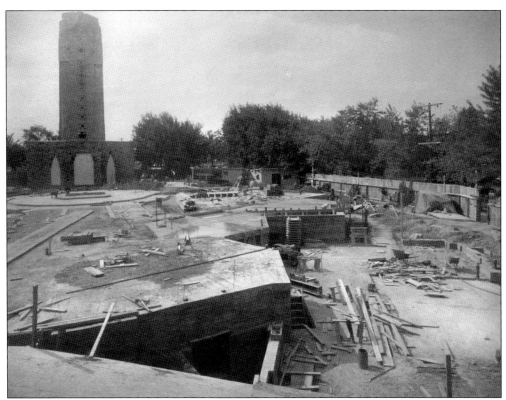

Construction began on the new church in 1933, becoming one of the most visible landmarks of Royal Oak. The tower and narthex, seen in the background, were completed in 1931. Below, beams begin to form the octagonal church. Eventually the large narthex connected the tower to the innovative octagonal nave, which seats 3,000, with the altar in the center. The main building is granite and limestone. The altar was to be in the center, an innovation that was 40 years ahead of its time. The original church was moved in 1929 to make room for the tower. It burned down on March 17, 1936, blamed on defective wiring. (Courtesy of National Shrine of the Little Flower.)

In March 1933, Father Coughlin made a radio attack on the bankers of Detroit. Early the next morning, a black power bomb exploded in the basement of his home, spoiling a pile of canned goods and shaking Father Coughlin out of bed. A police guard was then sent to protect Coughlin and his home.

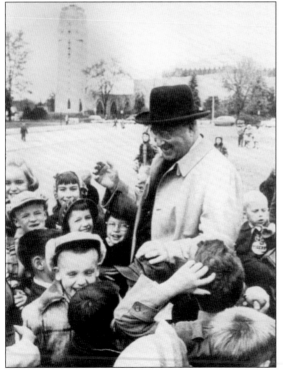

According to church officials, Father Coughlin would frequently take time to visit with students at the Shrine Elementary School across the street, something he enjoyed. Father Coughlin retired in 1966 and died October 27, 1979. The National Shrine of the Little Flower started with 28 families in 1926. Today church officials report there are more than 4,000 families.

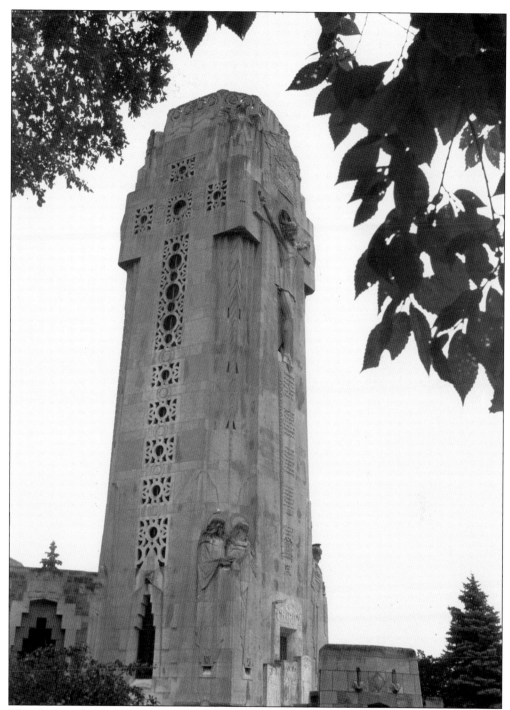

The 104-foot charity crucifixion tower forms a gigantic cross with the carved figure of the crucified Christ facing Woodward Avenue and can be seen for miles. It is connected to the octagonal church building by the narthex. In 1998, the U.S. bishops' conference declared the site a national shrine, one of only five in the country according to the church's Web site.

By 1889, a building known as St. Mary's Church was constructed on the southwest corner of Fifth and Main Streets. By 1909, the need for a growing parish arose, and a site was purchased on South Lafayette Street between Seventh and Lincoln Streets. In 1910, a rectory was built. By 1915, a combination church and school was erected. A high school followed. The current church was built on the site in 1954, its bells chiming for blocks around.

The First Baptist Church of Royal Oak was founded in 1838 by 14 friends who were members of Baptist churches in Troy, Bloomfield, and Mendon, and the first church was built on the corner of Third and Main Streets, where it stood for 80 years. The building was used for 36 years and then sold to the German Lutheran Church who then sold it to the Royal Oak Township to be used as the township hall. The congregation constructed a new building on the site of the present church at North Main Street and University Avenue, and in 1964, the church celebrated its 125th anniversary with a remodeled and expanded church.

First Congregational Church of Royal Oak was founded in 1842, and the first services were held in the First Baptist Church on the corner of Main and Third Streets. Meetings were then moved to a schoolhouse and next to the Methodist Church on South Washington Avenue. Finally in 1867, the congregation purchased the Presbyterian Church on the west side of Main Street between Third and Fourth Streets, as seen at right. The church was dismantled and reerected on the west side of Main Street between Third and Fourth Streets. (Courtesy of First Congregational Church of Royal Oak.)

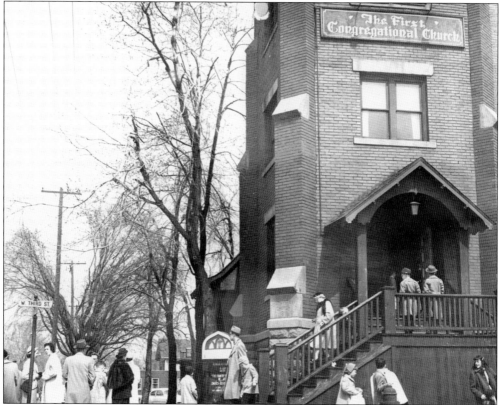

In 1911, the site of the First Congregational Church was sold and a new site at the northeast corner of Center and Third Streets was purchased. Hand-hewn oak beams from the 1911 church were used to support the first floor of the new church. In 1956, the site was sold to Royal Oak National Bank and the congregation moved to Crooks Road and Northwood, where a new church was completed in 1964. (Courtesy of First Congregational Church of Royal Oak.)

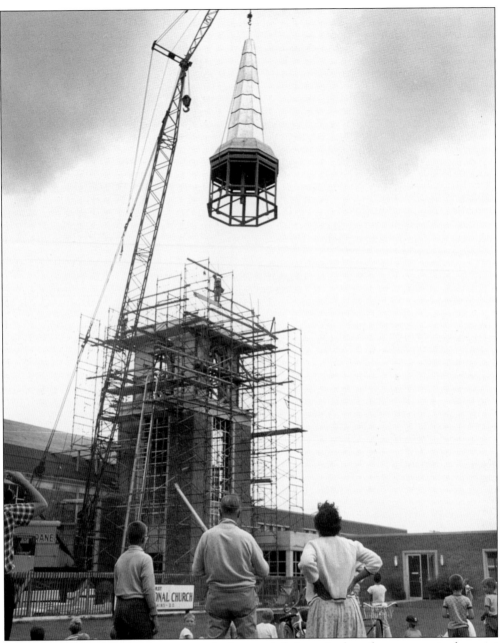

Hundreds of onlookers came out to watch the steeple being raised on the new meetinghouse at Crooks Road and Webster Street for the First Congregational Church on August 1, 1963. (Courtesy of First Congregational Church of Royal Oak.)

The idea to establish a Presbyterian church in the village began slowly with the first services held in the Masonic Temple on the southeast corner of Fourth and Williams Streets in 1914. A site for the church was picked where the Baldwin Theatre is today but was considered too small. A site on Henrie Avenue was chosen, and the church was opened in 1916 and expanded in 1924. (Courtesy of the Owen A. Perkins collection.)

The First United Methodist Church was organized in 1838 and held its first services in a schoolhouse on the northwest corner of Lincoln Avenue and Main Street. The first church, shown here, was dedicated in 1843 on the site of its present location on Washington Avenue. As the congregation grew, a larger church was built of brick, donated by Edwin Starr, who manufactured them in his own kilns.

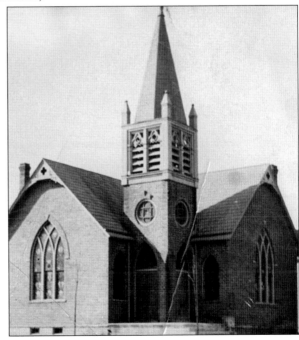

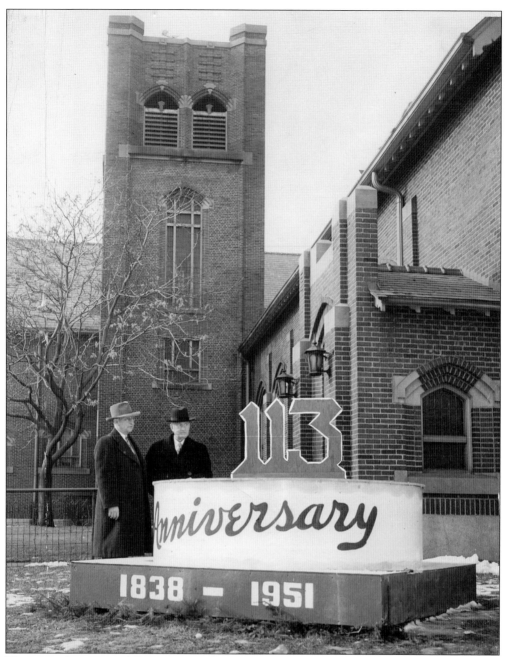

The original structure of this First United Methodist Church was erected in 1894 at the northwest corner of Washington Avenue and Seventh Street. In 1915, according to historian Owen A. Perkins in his book, *Royal Oak, Michigan—The Early Years*, the church went under another expansion to include a fellowship hall, parlor, gymnasium, auditorium, and several classrooms, as well as a kitchen and music department. On January 19, 1951, the church and its congregation celebrated its 113th anniversary with a large birthday cake.

Five

CITY OF TREES
1930 TO 1960

"Royal Oak is the place to come to, not pass through on your way to somewhere else" is the motto atop of the city Web site. City fathers and mothers are most proud of being designated "Tree City USA" by the National Arbor Day Foundation. The leafy goal began in the 1930s thanks to the publishers of the *Daily Tribune* and the 1937 Royal Oak City of Trees committee.

Floyd J. Miller, *Daily Tribune* publisher, arranged to have 50 acorns from the mighty oak in England, the legendary tree that inspired Royal Oak's name, sent to the town. Some sprouted on the way over. Detroit Zoo officials agreed to plant acorns in individual pots and shelter them from extreme weather.

In 1949, the saplings were planted at Thirteen Mile Road and Woodward Avenue in Memorial Park. Extreme care went into mulching with oak leaves, protecting from rodents and insects, and pruning them as they grew. For 20 years after, the city of Royal Oak provided a tree-planting program for residents. It allowed residents to purchase trees in spring at a modest cost. This helped and still helps maintain a canopy of thick green leaves throughout the town.

At the same time, the population sprouted in Royal Oak from 22,904 in 1930, to 47,000 by 1950, and a peak of 95,000 in the late 1960s. By this time, the city had 17 public parks, 29 churches representing 21 denominations, and a daily newspaper with a circulation of more than 60,000 readers. Arthur Hagman, in his sesquicentennial history of Oakland County, suggests the town's strength is its ability to offer urban living in a suburban atmosphere.

The Royal Oak City of Trees committee, led by Floyd J. Miller, publisher of the *Daily Tribune*, arranged in 1937 to have 50 acorns from the Royal Oak of England shipped to Michigan. Some sprouted on the way over. All were placed in pots at the Detroit Zoo. In 1939, the seedlings were planted in prepared soil, mulched with oak leaves, and in the 1940s, they were moved to Memorial Park where many of the trees still grace this preserve. (Courtesy of the Walter P. Reuther archives.)

Digging of another kind started in November 1936 for the basement for the rear section of the Montgomery Ward store at the southeast corner of Fourth Street and Lafayette Avenue. The Royal Oak Theatre, seen in the background, was playing the movies *Two in a Crowd* and *My Man Godfrey*.

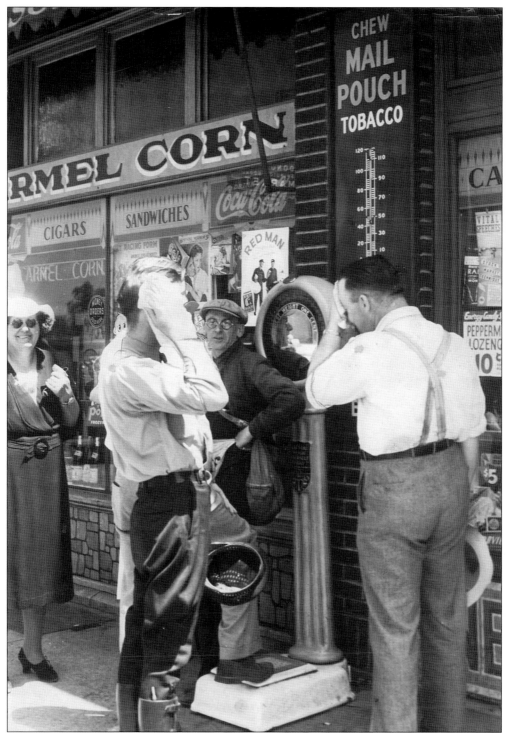

Nearly ever summer, people get together and proclaim it is hotter than ever before—they sweat so much they lose weight and gain some back frying eggs on the sidewalk. The street vendors in 1936 invited passersby to prove they actually did sweat off pounds by walking around.

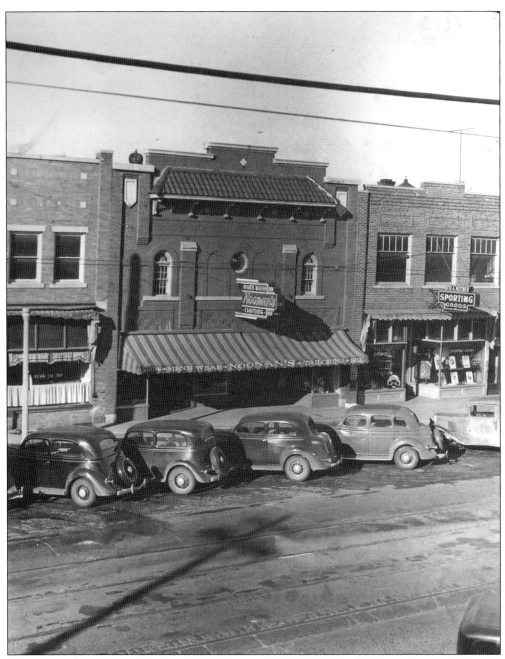

The canopied entrance to Noonan's Tailoring is shown here around 1938 after it took over the building at 320 South Main Street from the Royal Theatre, the city's second movie house. It opened September 14, 1914, after the first theater, the Idle Hour, which was across the street, closed. The fist movie was *The Spy* and admission was 10¢ according to an advertisement in the *Royal Oak Tribune*. The building is now the site of the popular Monterrey Cantina restaurant. The storefronts have stood the test of time as rounds of hopeful tenants stake their style and life savings on an entrepreneurial dream.

The majestic Washington Square Building occupied an entire block at the corner of Fourth and Washington Streets in downtown Royal Oak when it was built in 1928 as a luxury office and became a thriving center in the 1930s. The Royal Oak Theatre was designed by Rapp and Rapp and built for the Kunsky Chain that also erected the Birmingham, the Royal Oak, and the Redford Theaters. It was equipped with a Baron 3-10 organ. The theater was revived in the 1980s when the Hanna brothers and Don Tocco purchased and renovated the property. This photograph was taken in the 1950s.

The Madrid Hotel, a lovely deco-style building, was popular in the 1930s for housing out-of-town companies and salesmen to the downtown retail establishments. Today it houses Rise, a blue jean boutique; Bravo, a custom-fitting bra store; and Five Fifteen, a coffee shop and magazine store. The hotel upstairs offers a rare, affordable rate to low-income people.

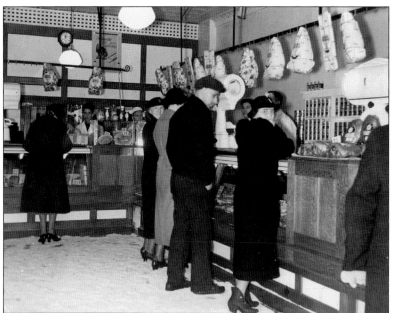

The easing of the Great Depression brought more people into the butcher's shop for prime cuts of meat.

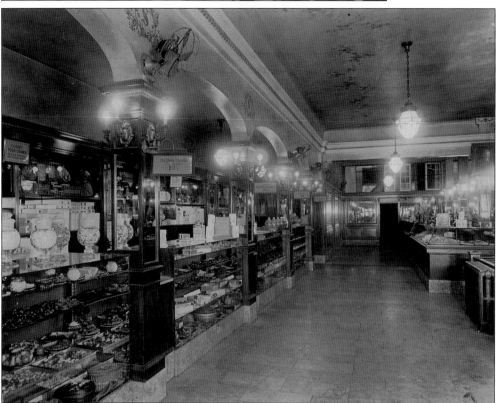

One of the earliest Washington Square tenants in the early 1930s was the regional candy chain Sanders Confectionery, which lasted into the early 1980s. Shoppers found retail candy at the ready and a soda fountain where bumpy cake, hot fudge cream puffs, and marshmallow sundaes provided a special treat. (Courtesy of the Sanders archives.)

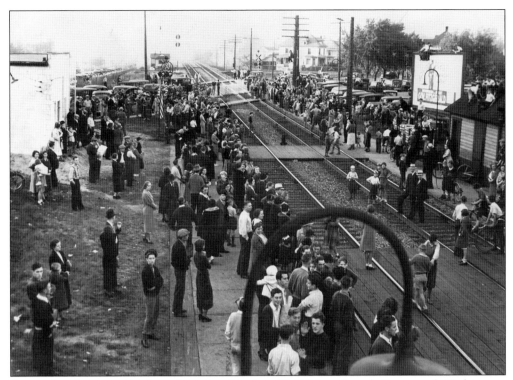

A crowd gathers outside the rail station October 16, 1936, at Fourth Street and Washington Avenue awaiting the arrival Pres. Franklin D. Roosevelt as part of his reelection whistle-stop tour. A billboard to the right is promoting Michigan governor Frank Fitzgerald, who was also running for reelection.

New housing in the 1930s often meant brick, Tudor-style bungalows from homes found in the Sears catalog or other major housing kit suppliers, then constructed by local builders. According to Michael W. R. Davis, author of *America's Favorite Homes*, the kit companies identified the most sought-after styles of their times.

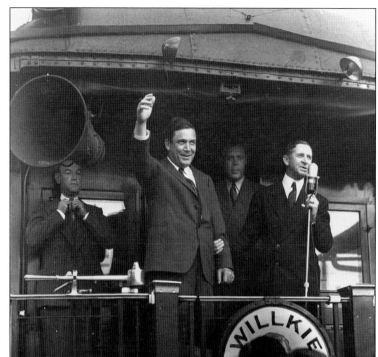

Wendell Willkie (left) conducted a whistle-stop tour in 1940 on the Grand Trunk Railroad stop in Royal Oak, accompanied by former Royal Oak mayor and U.S. congressman George A. Dondero. The presidential candidate lost to Franklin D. Roosevelt but the congressman's legacy lived on. He was the namesake of the town's first high school.

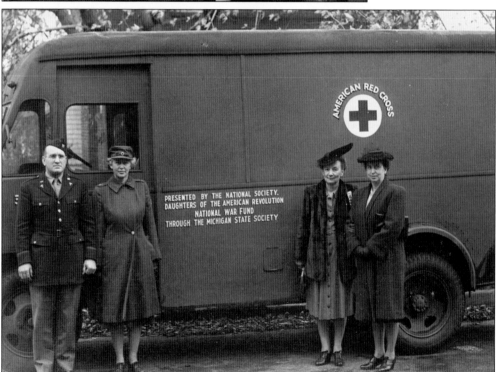

In 1943, Royal Oak's civil defense department accepted ownership of an American Red Cross vehicle, thanks to the generosity of the Daughters of the American Revolution. Volunteers held blood drives around the city and south Oakland County.

Postwar prosperity returns to Washington Avenue in this 1947 photograph looking south at a street lined with vehicles and people optimistic about jobs and a brighter future.

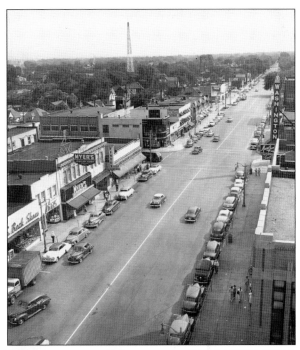

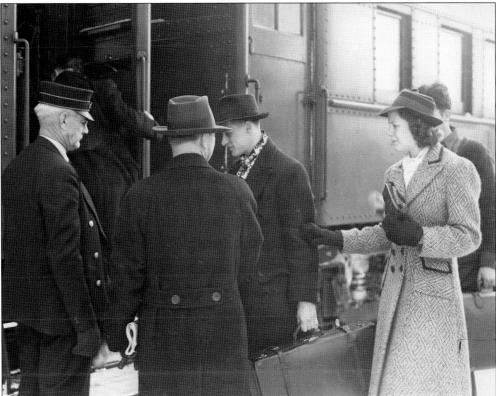

In a post–World War II era, businessmen traveled by passenger train to many destinations while their wives kissed them goodbye at the Grand Trunk station off Sherman Drive.

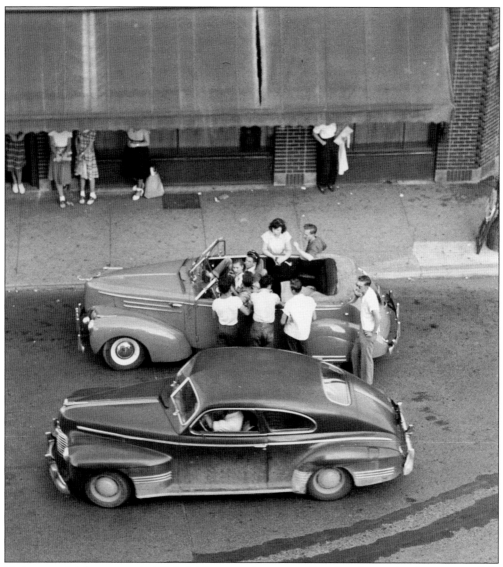

Quintessential downtown is delightful for teens that can walk, take a bus, or hitch an automobile ride, unlike the new suburbs, which require parents to drive teens to any destination. Flirting is always fun, with a promise of sharing a pizza or a soda at a shop nearby.

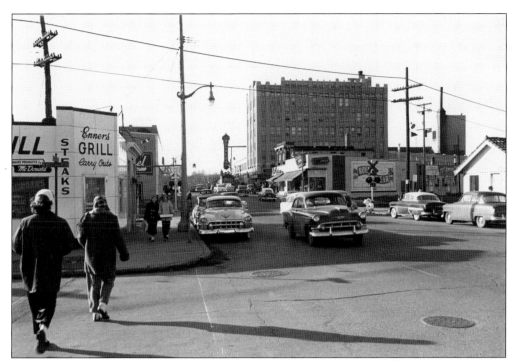

For more than 50 years, residents and visitors have found a hamburger stand at Fourth and Center Streets a delicious and inexpensive repast. Note the Royal Oak Theatre's marquee, which can be seen on the side of the Washington Square Building.

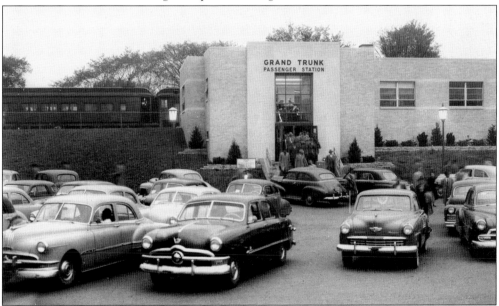

Royal Oak was among the few Oakland County towns that had a downtown commuter station—Sherman and Eleven Mile Roads—that saved workers the frustrating, often frightening bottleneck along daily trips to Detroit. Grand Trunk discontinued its passenger service in the mid-1970s when the Detriot Riverfront station became a parking lot for the towering glass-sided Renaissance Center.

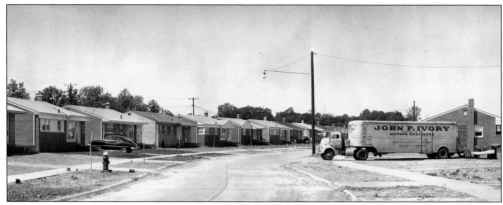

The moving trucks seldom stopped for long in the 1950s when Royal Oak grew from 60,000 to 95,000 residents thanks to excellent schools and proximity to jobs at the General Motors Technical Center in Warren, Chrysler Corporation in Highland Park, and the downtown Detroit offices. Notice that few trees were yet to be planted in this new housing development.

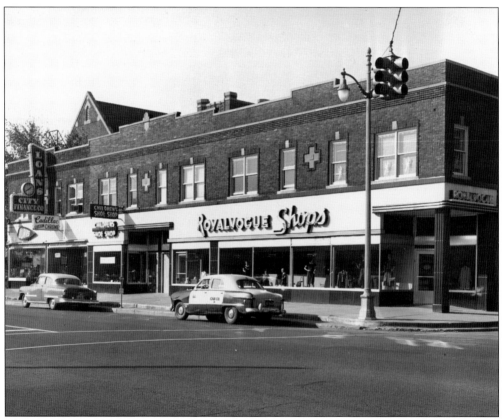

The Campbell Building at 600 South Washington Avenue has changed tenants over the years, but the structure has remained the same. In the 1940s, there was A and D Camera Shop, Arthur L. Snow Real Estate, and C. F. Groceries. By the 1950s (above), the building was home to Royalvogue Shops, a children's shoe shop, a chrome store for Cadillac, and a finance company. Today Pronto! Restaurant and its corner store have taken over the entire block.

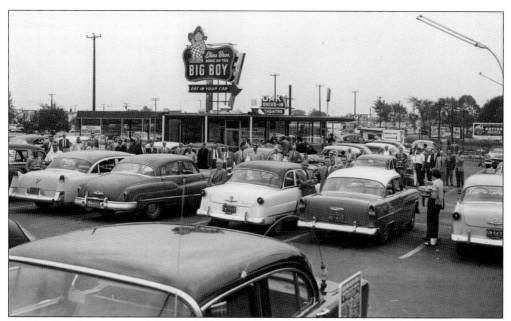

The Big Boy Restaurant at Normandy Road and Woodward Avenue enjoyed a 40-year run. This flagship store served double-decker sandwiches, shakes, and onion rings to successive rounds of motorists. It started with carhops wearing roller skates and fed 5,000 customers a week on a double-sized lot. It was sold in 2004 to become a strip mall and a bank branch. (Courtesy of Anthony Ambrogio collection.)

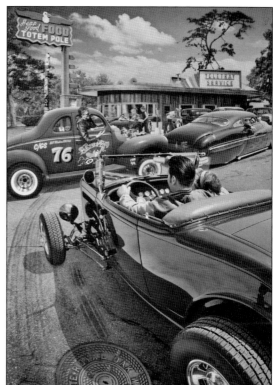

Fifties cruisers on Woodward Avenue set the stage for the later movie *American Graffiti*. Jerry Farber, a Detroit photographer, remembers the best of the funny cars and cruisers who frequented the Totem Pole with a memorial poster he sells at the annual Woodward Dream Cruise in August. (Courtesy of Jerry Farber Photography.)

Woodward Avenue in the 1950s was poised to become cruising capital of the Midwest, or even, perhaps, of the nation, because of infrastructure enhancements conducted over the decades. With eight full lanes and a boulevard in the center, it could accommodate massive numbers of motorists. Numerous motels, gas stations, and fast food restaurants flanked the sidelines.

Six

Cultivating Culture
Health and Art

Billboards and advertisements proclaim, "You Ought to Know a Beaumont Doctor," yet few people know how a regional hospital named after a upstate New York physiologist came to be located on a longtime Royal Oak farm and become a facility known nationwide for medical excellence and the employer of more than 11,000 people.

In 1943, when mothers delivering babies and grandfathers suffering heart attacks could not wait out the drive to downtown Detroit or Pontiac, the South Oakland Hospital authority targeted the Royal Oak site. Opposing them was a group seeking a Bloomfield Medical Center at Woodward Avenue and Adams Court. The groups merged to consolidate fund-raising and construction of buildings on a 55-acre farm owned by Asher and Harriet Parker. Groundbreaking occurred in 1953 with the Beaumont name proudly affixed to its cornerstone. Beaumont Hospital continues to grow and has doctor offices scattered about Royal Oak and plans to demolish the shopping plaza nearby for more hospital services.

Nurturing patients with cultural splendor occurred in the earliest days of Beaumont Hospital with the installation of a Marshall Fredericks bas-relief sculpture on a prominent exterior wall. Fredericks, the city's most esteemed sculptor, opened a studio in Royal Oak a half mile from the hospital, and his work is seen all over town, including the Detroit Zoo and next to the Royal Oak Library.

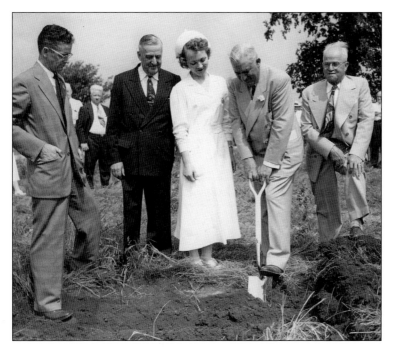

Groundbreaking for William Beaumont Hospital occurred on June 19, 1953, with Mark Beach (holding shovel), executive director of the Greater Detroit Hospital Fund. From left to right are H. Lloyd Clawson, board member; Irving B. Babcock, board member; Colleen Cole, student nurse; Beach; and E. A. Tomlinson, hospital board president. (Courtesy of William Beaumont Hospital.)

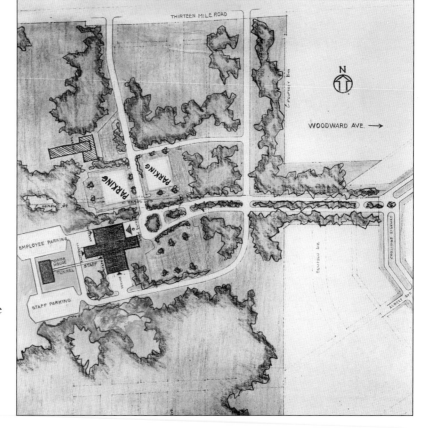

An architect's drawing shows the precise location of the planned five-story hospital, west of Woodward Avenue and just south of Thirteen Mile Road, accessible to Royal Oak, Berkley, Clawson, Oak Park, Ferndale, Madison Heights, and Hazel Park.

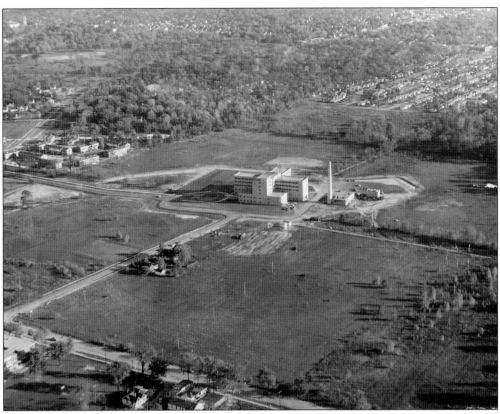

An aerial view of the hospital grounds in 1955 shows the last remaining portion of the Parker family homestead. At the time it was still being used by Ralzemond Parker and his sister Doris, according to Muriel Versagi of the Royal Oak Historical Museum. Parker Elementary can be seen in the lower left corner on Thirteen Mile Road, and in the far upper left-hand corner is a barely visible Shrine of the Little Flower at Woodward Avenue and Twelve Mile Road. (Courtesy of William Beaumont Hospital.)

Modern hospital construction gave patients private or semiprivate rooms as opposed to the wards found in many older hospitals. Picture windows offered a view of the Parker farmhouse, but not for long because the regional hospital added buildings and parking structures in rapid succession. The nurse is Marjory Dolezell from Royal Oak. (Courtesy of William Beaumont Hospital.)

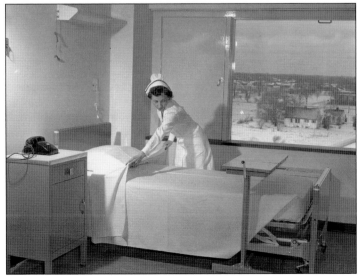

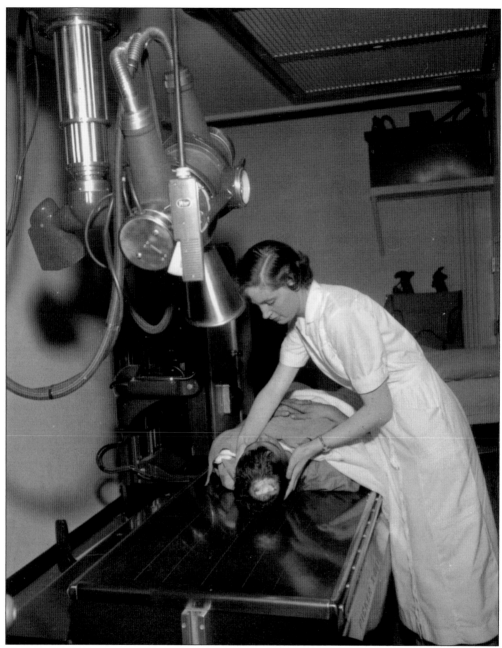

Hailed as a "tribute to modern medicine," the newly opened hospital featured an extensive X-ray department and an advanced obstetrics center. Within 24 hours of Beaumont opening, its first baby, Michael Welsh, was delivered. In the first week, the hospital delivered 31 babies, performed 41 surgeries, and served 129 patients, according to hospital officials. (Courtesy of William Beaumont Hospital.)

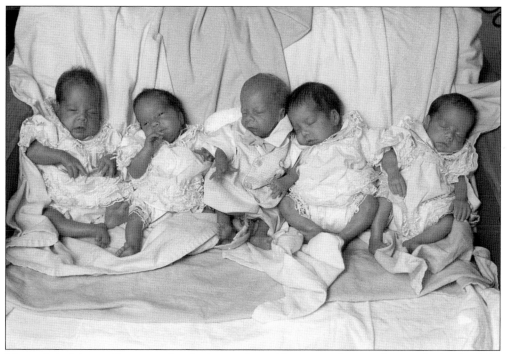

Through its history, Beaumont has had several notable stories. Among them is the birth of the L'Esperance quintuplets on January 11, 1988. They were Michigan's first quintuplets conceived via in vitro fertilization in the hospital's own gynecology and obstetrics laboratory. Above, the quintuplets are shown shortly after birth and below, at age 17. From left to right are Alexandria, Veronica, Raymond, Danielle, and Erica. (Courtesy of William Beaumont Hospital.)

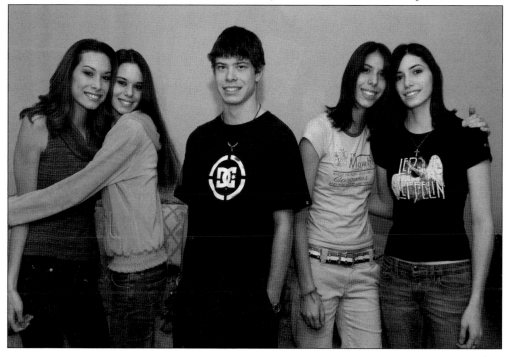

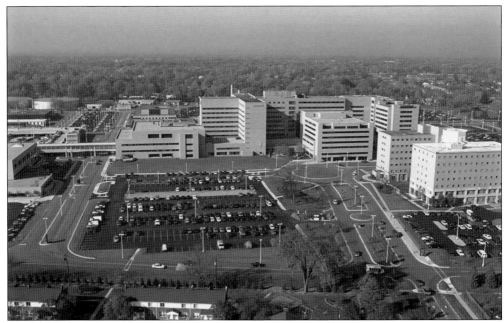

Expansion continued at Beaumont as the population in Metro Detroit soared. By 1996, the hospital had added several new buildings, including a second medical office (1990), north tower (1977), east tower (1994), an expansion of the OB services area, and a cancer (1989) and imaging center (1995). (Courtesy of William Beaumont Hospital.)

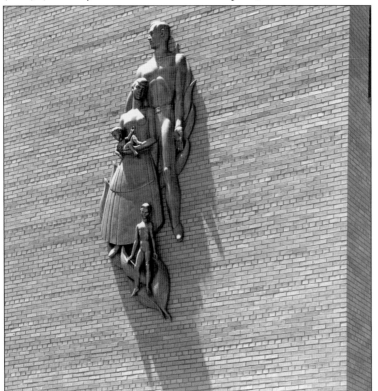

The Family was a bas-relief sculpture designed by world-renowned Royal Oak sculptor Marshall Fredericks. Its image stands like a sentinel outside Beaumont's central tower. (Courtesy of William Beaumont Hospital.)

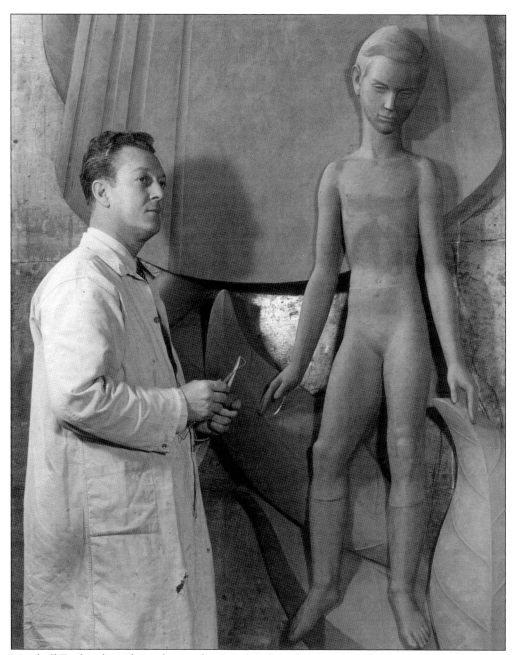

Marshall Fredericks is shown here in his Royal Oak studio in 1954 with his sculpture *The Family*. It became a gift to the hospital from Lola Jennings Erb in memory of her late husband, Lewis G. Erb. The Erbs are among the founding families of Royal Oak who ran a general store and a lumberyard for decades. (Photograph by Maurice C. Hartwick; courtesy of Marshall M. Fredericks Sculpture Museum Archives, University Center, Michigan.)

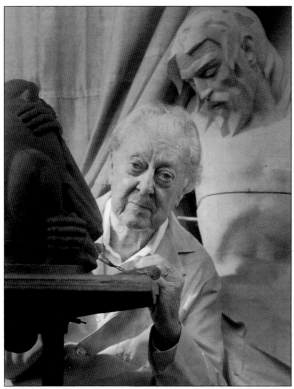

Marshall Fredericks poses in his studio while creating faces for *Star Dream Fountain*, his last public commission depicting a man and woman rising beyond earth's gravitation to their eternal destiny. (Photograph by Balthazar Korab; courtesy of Balthazar Korab Ltd. collection.)

The art studio of Marshall Fredericks stood on the northwest corner of Woodward Avenue and Normandy Road in Royal Oak from 1945 until his death in 1998. Fredericks created many of his well-known sculptures in this ivy-covered brick structure, including the *Spirit of Detroit* that anchors the western courtyard of the Coleman A. Young Municipal Building in downtown Detroit and also the life-size *Boy and Bear* at Northland Mall in Southfield. His studio was torn down after his death and replaced with an office building. (Photograph by Maurice C. Hartwick; courtesy of Marshall M. Fredericks Sculpture Museum Archives, University Center, Michigan.)

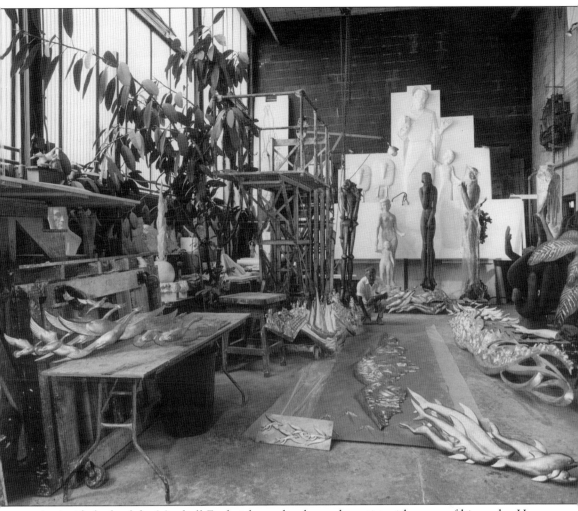

An inside look of the Marshall Fredericks studio shows the artist with many of his works. He taught in Cleveland and at the Cranbrook Academy of Art in Bloomfield Hills, Michigan, for more than nine years. (Photograph by Maurice C. Hartwick; courtesy of Marshall M. Fredericks Sculpture Museum Archives, University Center, Michigan.)

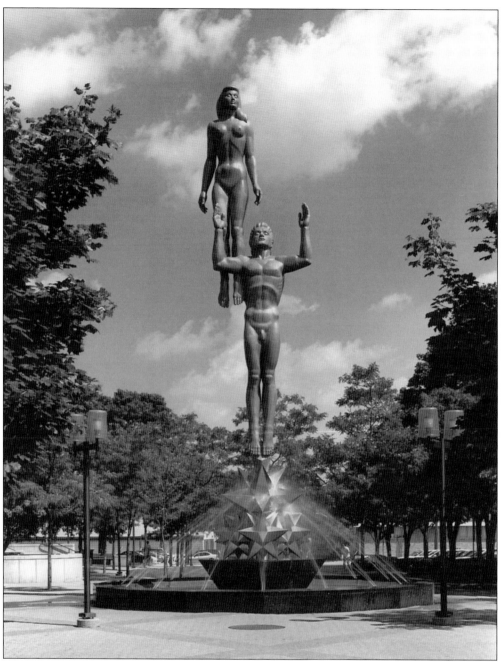

The 40-foot bronze *Star Dream Fountain*, with a marble and chrome base, occupies a park between city hall and the Royal Oak Library. Dedicated in 1997, it began as an idea by former Royal Oak mayor and art teacher Barbara Hallman, who initiated the project in the mid-1980s. Once erected, at a cost of $750,000, the nude statues created a great deal of controversy between those who wanted to cover up parts of it and the cultural champions who won the aesthetics battle. (Photograph by Balthazar Korab; courtesy of Balthazar Korab Ltd. collection.)

Seven

Nurturing Children
Schools and More

The first schoolhouse in the village, according to the *History of Oakland County*, was a small frame house built in 1850 at Main Street and Lincoln Avenue. Soon seven one-room "district" schools popped up across the township. In 1913, Royal Oak High School opened on a 5-acre tract just north of Eleven Mile Road. By the early 1920s, it became obsolete and the new Royal Oak High School opened in 1927 on South Washington Avenue.

A rapidly growing student population pushed the district to open a second high school—Clarence M. Kimball—in 1957 to accommodate the expanding neighborhoods in the northern end of the community. Almost immediately, an intense rivalry began between Kimball and the newly named George A. Dondero High School. According to the district officials, at their peak, both institutions had enrollment of over 2,000 students. But declining enrollment throughout the district forced the closure of Dondero High School in 2006, and the student populations of the two schools were merged into the Kimball facility.

Extensive renovations were made to accommodate the surge of students, after which the high school was renamed Royal Oak High School. The name change was made not only to signal a new beginning for the city but also to quell growing concerns that old school rivalries would prompt hallway tensions and division among students.

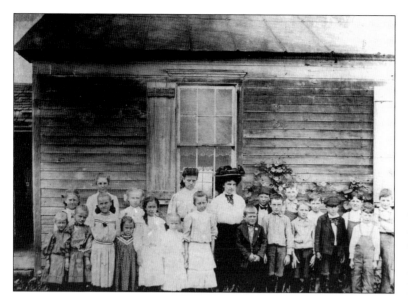

Around 1906, students from Township District No. 5 held classes in this frame building, known as Williams School, at the northeast corner of Thirteen Mile and Rochester Roads at the epicenter of the first Royal Oak community called Chase's Corners. (Courtesy of the Owen A. Perkins collection.)

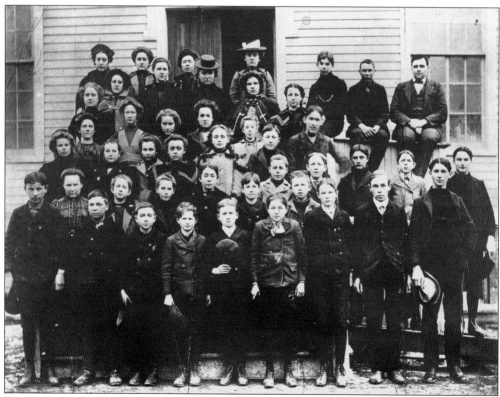

Students from the c. 1902 Royal Oak High School class pose in front of Union School. Among them is George A. Dondero (first row, far right), who would later serve as the village's first mayor. He had availed himself to a Royal Oak education and said in a letter to a friend: "The memories that cling to that little school building are sweet to me yet. It may not have been a fancy school, but in it were taught the fundamentals of and given the best of an education."

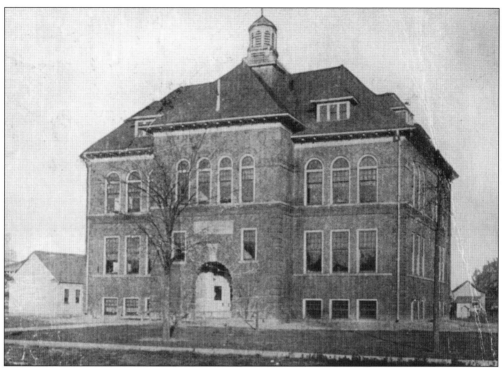

Union School, at the southeast corner of Washington and Lincoln Avenues, now the site of Oakland Community College, was the first combined grade and high school, thus the name. It was built in 1902 and enlarged in 1910. The first and second floors had nine rooms, with three rooms on the upper floor devoted to high school and eighth grades. It was replaced in 1924 by the Washington School.

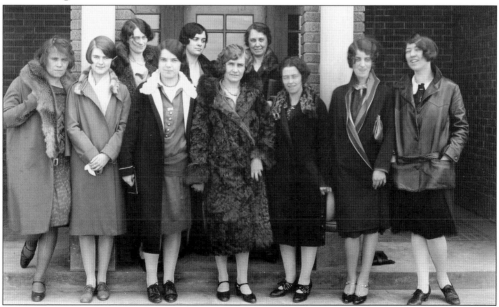

Teachers from 1927 pose in front of Benjamin Franklin Elementary School on Mohawk Avenue. By 1930, there were a dozen schools across Royal Oak's neighborhoods.

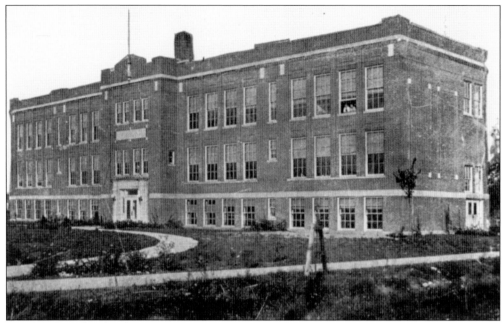

Royal Oak High School was open on Main Street north of Eleven Mile Road in 1915 thanks to a bond issue in 1912 for $3,500. It later became Clara Barton Junior High. It closed permanently in the fall of 1979 and was demolished soon after that. (Courtesy of the Owen A. Perkins collection.)

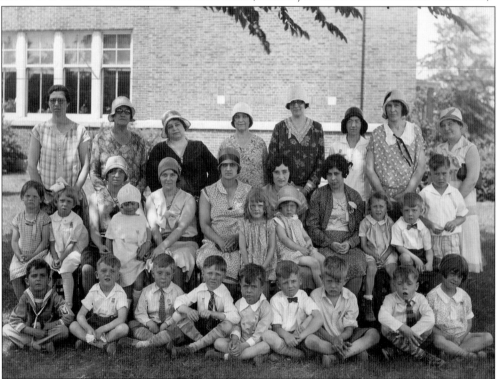

Students and teachers from an elementary class at Northwood pose outside their school on Twelve Mile Road in 1930.

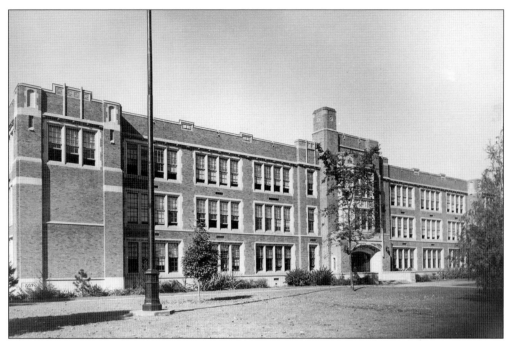

"Enter here to learn, go forth to serve" is etched in the entrance of the new Royal Oak High School, built in 1927 on Washington Street, just north of Eleven Mile Road, to accommodate a growing student population. It remained Royal Oak High until 1957 when Kimball High was opened and Royal Oak High was then named after longtime city leader George A. Dondero.

Amid a lively march of "Stars and Stripes Forever," the Royal Oak High School takes to Cass Field to build crowd momentum for the Acorns, the school football team. Nearly everything in town has oak, acorns, thistles, twigs, and leaves in memory of Michigan's first territorial governor Lewis Cass, who proclaimed the area for its "Royal Oak." The field is named for him, as is a downtown Detroit high school, Cass Technical High School.

Compare the clothing style and the faces of high school seniors at Royal Oak High School in 1931 to those of Dondero High School in 1968 during their visit to the U.S. Capitol in Washington, D.C. One group endured the extreme hardship of a Great Depression. The other group experienced

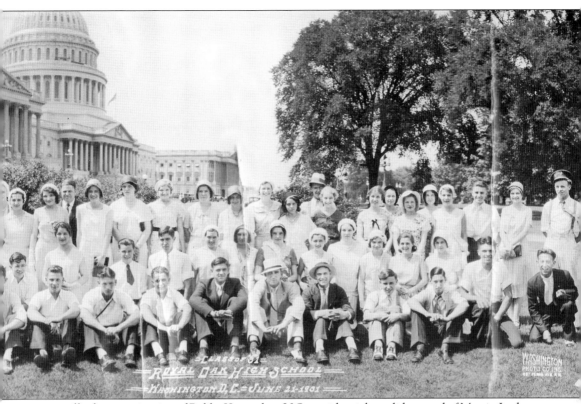

viscerally the assassination of Bobby Kennedy, a U.S. presidential candidate, and of Martin Luther King Jr., a charismatic civil rights advocate, all shown on television with live coverage.

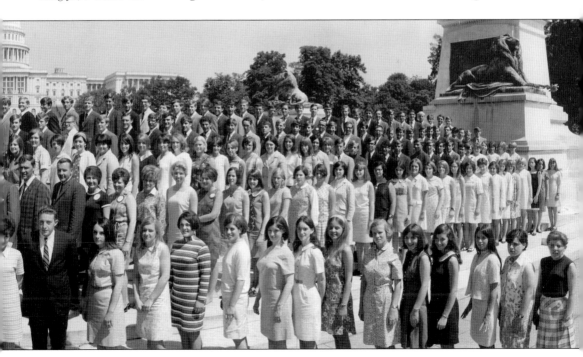

Watching a football game between Dondero and Kimball High School in 1963 are George A. Dondero (standing in bow tie) and Clarence M. Kimball (wearing trench coat on the far left.) Dondero was the village's first mayor and later a U.S. congressman. Kimball served on the city commission and was on the school board for 11 years, serving as president for nine consecutive years. (Courtesy of the Todd Cameron collection.)

The Royal Oak High School Acorns and the Birmingham Maples played in an annual rivalry game for the Little Brown Jug on Thanksgiving Day 1940, in one of the most hotly contested matches of Oakland County. Royal Oak's Bobby Martin raced onto the field with a borrowed shoe to kick the winning field goal on the last play of the game that ended 3-0, as the crowd broke out in cheers and the band played loudly. (Courtesy of the Todd Cameron collection.)

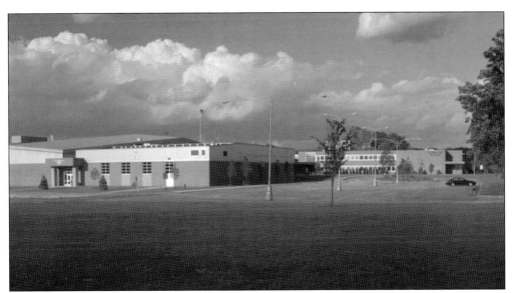

Clarence M. Kimball, longtime school board president and city commissioner, achieved 50 years of fame with his name affixed to the newest high school on Crooks Road north of Thirteen Mile Road. It opened in the fall of 1957 and merged with students from the shuttered Dondero High School in 2006. It became Royal Oak High School (shown above), the name the town started with in 1915. Go Ravens! (Courtesy Royal Oak Neighborhood Schools.)

Football victories infuse a whole town with excitement in the 1960s. Kimball's varsity women march through town—in jackets purchased from Lawson's Sporting Goods on Washington Avenue before the Kimball Knight's big game against the Southfield High School Blue Jays. (Todd Cameron collection.)

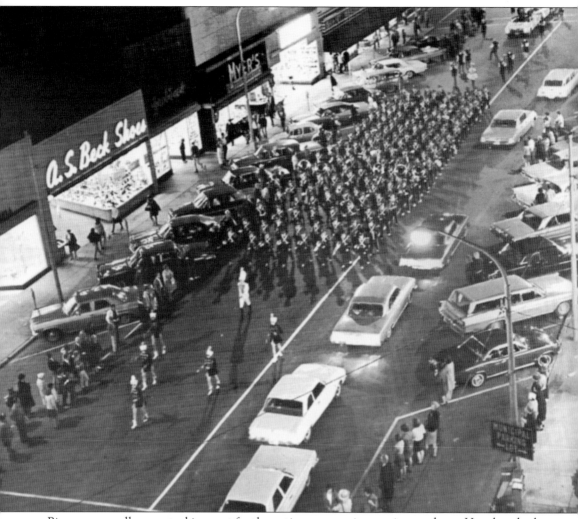

Big games usually meant a big event for the entire community, not just students. Here hundreds of residents line Main Street to watch Kimball's marching band lead the parade of students and floats on Friday night before the homecoming game in 1966.

Kimball High School football captains Eric Goullaud, Gene Meunch, Lloyd Harpe, Kurt Neumann, Don Hagel, and Larry Vernier pose like a popular harmonic quartet, letter sweaters and all, for an advertisement for Royal Pontiac. Car dealers in 1962 bought advertisements in the yearbook and helped cheer the four home teams at Shrine, St. Mary's, Dondero, and Kimball. (Courtesy of the Todd Cameron collection.)

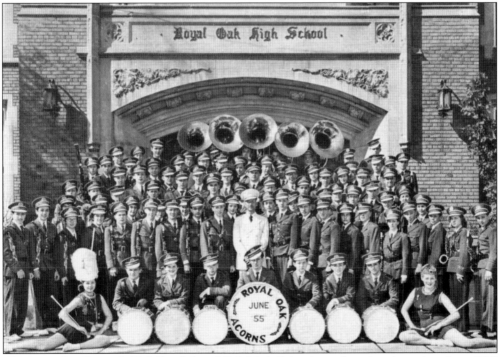

This is not Sgt. Pepper's Club Band. Royal Oak High School marching band members from 1955 pose in front of the high school dressed, prepared, and ready to perform.

Above, Mary Lyon Junior High at the northeast corner of Thirteen Mile and Rochester Roads was one of three junior high schools named for famous women, along with Jane Addams and Clara Barton. A McDonald's restaurant now occupies the site. Below is Addams Elementary and Junior High School on West Webster Road. By 1956, the school district had grown to 22 schools, including public and parochial.

The legend of the mighty oak that named the city continues in this Mary Lyon Junior High classroom with annual celebrations of Arbor Day. In 1971, the town, named for its giant tree, is depicted by students who learn Royal Oak is resplendent in elm, willow, and umbrella trees. In Memorial Park, the descendants of the English oak tree that inspired the name continue to flourish.

Royal Oak has had several notable graduates throughout its history and Dondero High School had a whole wall of pictures that are now kept in the Royal Oak Historical Society. Among the famous, Tom Hayden, class of 1956, became one of the founders of the student activist group Students for a Democratic Society, was married to Jane Fonda, and served in the California State Assembly and the state senate. He is an author of 17 books. (Courtesy of Ann Maudlin.)

Glenn Frey, class of 1966, was a founding member of the rock group the Eagles and a gifted solo artist. At Dondero, he was on the wrestling team but found music to be his following. He taught himself to play the guitar, and his first band was called the Disciples. Glenn has said it was just "three guys with acoustic guitars" and did not last long. (Courtesy of Ann Maudlin.)

Oliver (Ollie) Fretter, class of 1947, forged one of the largest chains of big box appliance stores in southeast Michigan for three decades when televisions surged in popularity and discounting pitches ruled the media. He used the medium in its most theatrical sense by insisting he had the lowest prices in town. "I'll give you five pounds of coffee if I can't beat your best deal. The competition knows me, you should too!" (Courtesy of Ann Maudlin.)

Judith Guest, class of 1954, is a best-selling author, most notably for *Ordinary People*, a novel exploring teen suicide that was published in 1976 and became an Oscar-winning movie directed by Robert Redford. In high school, Judith "Judy" was on the yearbook staff. She taught first grade in Garden City after graduating from the University of Michigan. Other novels include *Second Heaven*, *Killing Time in St. Cloud*, *Errands*, and *The Tarnished Eye*. (Courtesy of Ann Maudlin.)

In August 1982, Oakland Community College opened a $12 million enclosed campus that stretches an entire city block just north of Lincoln Avenue, from Washington Avenue and Main Street. The four separate buildings, which are linked and include a fully enclosed glass mall, serve nearly 340,000 residents from 10 south Oakland County communities. Its specialties include pottery and photography, prompting an annual show on Washington Avenue each summer. (Courtesy of Oakland Community College.)

Students study in the circular two-story library supported by a central beam with supporting arms branching into the ceiling. According to George Cartsonis, the college communications director, students symbolically call the structure the "Tree of Knowledge." Indeed, Royal Oak is a center of knowledge, one of the few suburban cities with thriving day care, K–12, and a campus, all accessible by pedestrians. (Courtesy of Oakland Community College.)

Eight

BRANCHING OUT
THE 1960s

What Royal Oak residents do not see or often take for granted—the infrastructure of the town and surrounding area—contributes mightily to its growth and to the safety of the citizens. City planning began from the time closed-coupe vehicles motored into town and people stayed to raise families and run businesses. With expansion came the need for roads and sewers.

Of major importance, the city fathers and railroad executives in the 1920s authorized a relocation of 9 miles of the Grand Trunk Railroad from Woodward Avenue at a cost of $7 million, relocating it three-quarters of a mile east of the original location. Woodward Avenue or "M1" became a 204-foot, eight-lane superhighway for cruisers of all ages who enjoyed its restaurants and grassy boulevard.

Another extraordinary change started in the early 1940s when the Southeastern Oakland County Sewage Disposal System was established to help accommodate the explosive growth in Royal Oak and the 11 adjacent towns in a 37-square-mile area. The first surge of residents built shallow wells for water supply, septic tanks for waste disposal, and shallow ditches for storm-water removal. But the sewers were exceeded by ever-expanding volumes of storm water and sanitary sewage discharged from nearby drains.

Then in the 1960s, the Twelve Towns Relief Drains began construction with the help of Hubbell, Roth, and Clark, Inc., and highly complicated drain laws and tax provisions. In the 1970s, the open ditch Red Run was replaced by two concrete boxes, each 18 feet high by 30 feet wide to hold and disinfect storm water and drastically reduce the overflow. On top of the retention boxes, the firm built the nearby Red Oaks Golf Course and the Red Oaks Water Park, delighting recreational enthusiasts of all ages.

Flooded basements were the scourge of Royal Oak residents. As population increased, the civic leaders in town and in county government saw the need for a drain system to separate and disinfect sanitary waste and contain storm water. This 1962 photograph by Win Bruno shows construction managed by Hubbell, Roth, and Clark, Inc.—Birmingham-based civil engineers on the Red Run Drain—so big a cement mixer could drive inside. (Courtesy of Hubbell, Roth, and Clark collection.)

Where the drain traveled underneath I-75, workers reinforced the cement to accommodate the automobiles whizzing across. The Twelve Towns Drain, according to Hubbell, Roth, and Clark, Inc., archives, had a capacity to store 32 million gallons of water. Still, more drainage improvements were needed. (Courtesy of Hubbell, Roth, and Clark collection.)

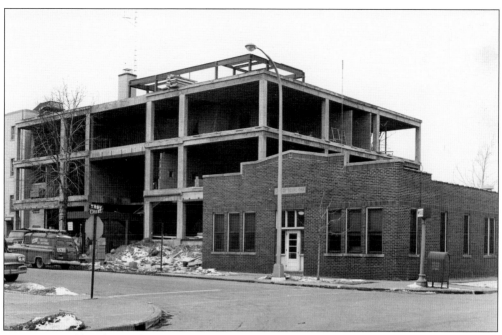

Juxtaposing old and new, the old brick city hall building gives way to a new, modern structure in the civic complex just east of downtown that will include city hall, 44th district court, a library park honoring veterans, and the Royal Oak Market.

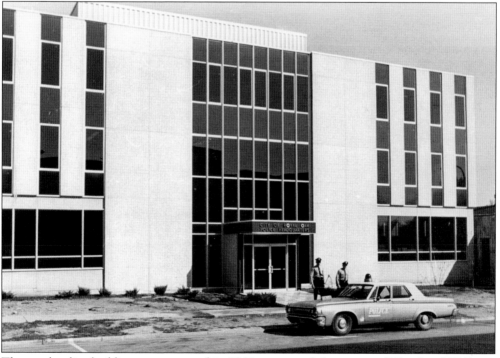

The regal police building—constructed in 1964—occupied the corner of Third and Williams Streets, across the street from the new *Daily Tribune* Building constructed in 1951. The Royal Oak Public Library opened a year later on the same city block.

The Royal Oak City Commission took a firm role in approving growth and guiding the budget. In 1966, the mayor was L. Curtis Potter and the commissioners included James P. Cline, Wallace F. Gabler Jr., Vernald E. Horn, Barbara Mitchell, Grant L. Maudlin, and Robert F. Patnales.

A salute to the founding father of modern Royal Oak included the installation of a portrait of the city's first mayor, George A. Dondero, second from the right. Also included in the ceremony were Dondero's son Robert Lincoln Dondero, far left; Mayor L. Curtis Potter; and Congressman William Broomfield, center. George Dondero died in 1968.

Bulldozers seldom slept in 1960s Royal Oak when the very face of the city underwent a massive modernization. In 1966, the town greeted a new U.S. Post Office and a south Oakland County branch of the YMCA.

The municipal parking lot behind city hall along Williams Street in the mid-1960s is missing a familiar site these days—parking meters. Also, note the lot to the north between Second Street and Eleven Mile Road has yet to be developed. To the north are the wood rafter beams of the Main Theatre under construction.

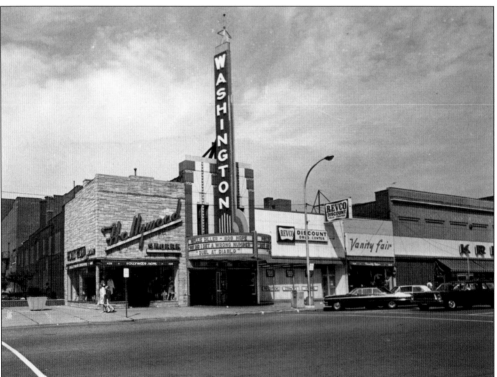

The Washington Theatre on the west side of Washington Avenue and Fifth Street is flanked by several popular shops in the mid-1960s, including Hollywood Shoppe, Revco Discount drugstore, Vanity Fair, and Kresge's. The theater—renamed the Baldwin from its original use—is occupied today by Stagecrafters, a community theatrical group that performs numerous musicals and dramas.

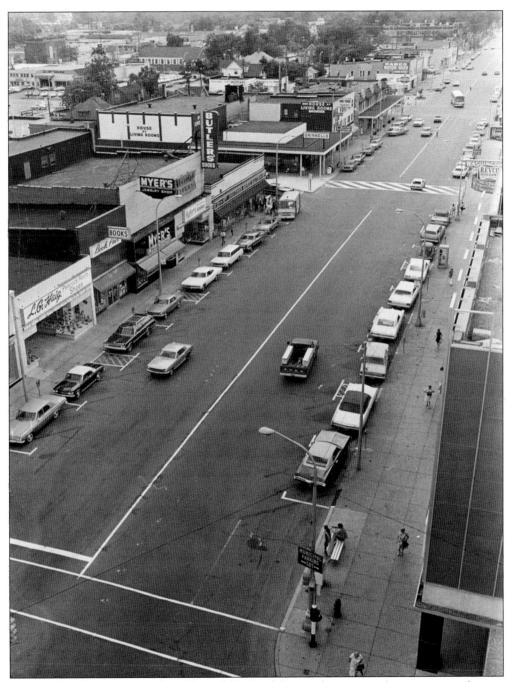

A view of Washington Street from Eleven Mile Road shows a thriving retail community with every storefront occupied. People shopped at shoe stores with individualized attention, and bookstores chock full of out-of-town and local newspapers greeted a literate society.

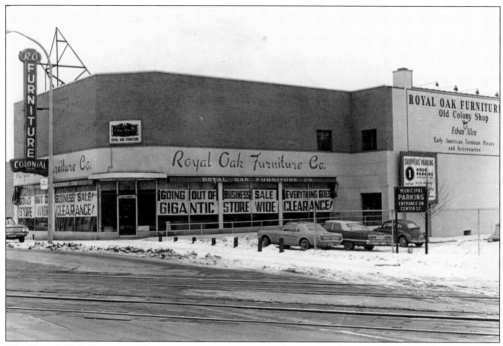

The Royal Oak Furniture Company was a mainstay downtown for many years before its going-out-of-business sale (above) in the late 1960s. The store was on Washington Avenue, across from the Washington Square Building, just south of the U.S. Post Office. The building later became the Black Forest restaurant and today has an Oriental motif as the Peking House.

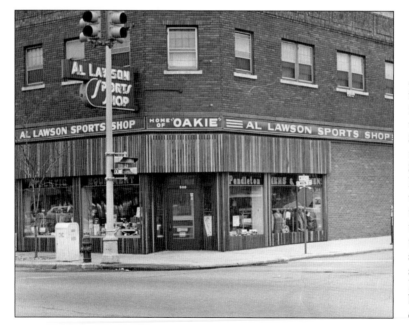

A popular hangout for student athletes in the 1960s was Al Lawson's Sports Shop on the corner of South Main and Fifth Street. It was known as the "Home of the Oakie," and the store supplied athletic equipment as well as clothing. Barnes and Noble bookstore now occupies the site.

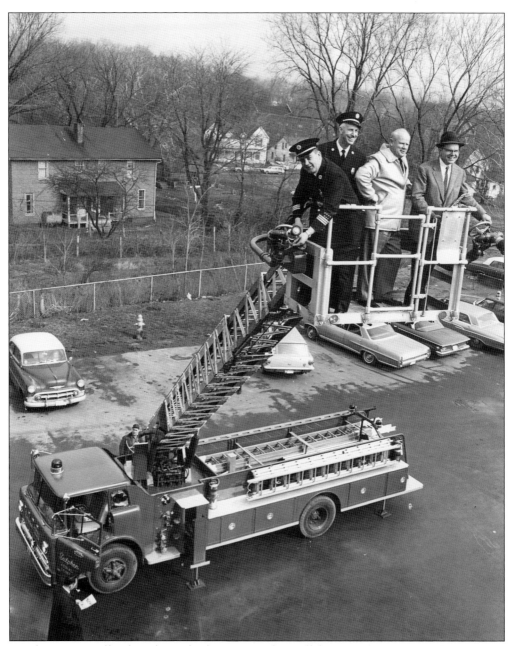

Fire department officials and civic leaders in 1962 show off their new fire engine with a 100-foot-long aerial ladder to serve a variety of citizen and business emergencies. The vehicle lasted over 30 years of dedicated firefighting at its Seventh Street and Williams Street headquarters.

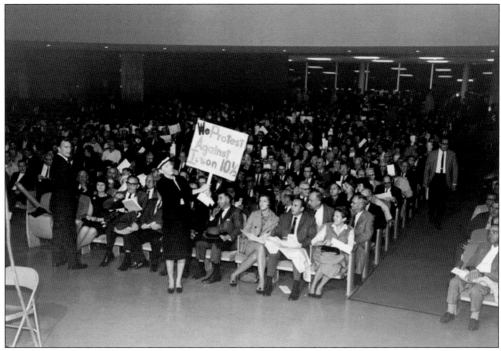

The I-696 highway may stand as the most contested highway in southeast Michigan because it cut through densely populated suburbs, the Detroit Zoo, and the interests of thousands of residents. A full house of constituents attended a 1966 meeting in Southfield called by then governor George Romney and staffed by the Michigan Department of Transportation. They tried to resolve disputes over the freeway's alignment. Such complications meant it would take another 25 years to open the depressed road to traffic, where it was an instant success for east-west motorists. (Courtesy of Michigan Department of Transportation archives.)

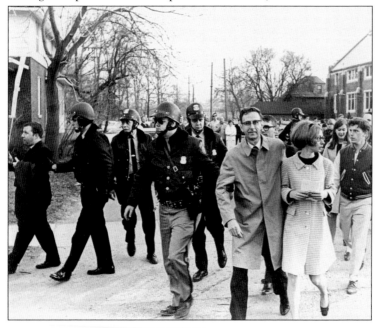

In 1968, the riot police were called out to quell a protest following the death of U.S. presidential hopeful Bobby Kennedy. Later the singer Dion would ask the question, "Anybody here see my old friend Bobby?" in the salute to felled leaders, "Abraham, Martin and John." Folk singers in Royal Oak would recall this tune nightly at folk tavern Alden's Alley, now operating as Monterrey, a Mexican cantina.

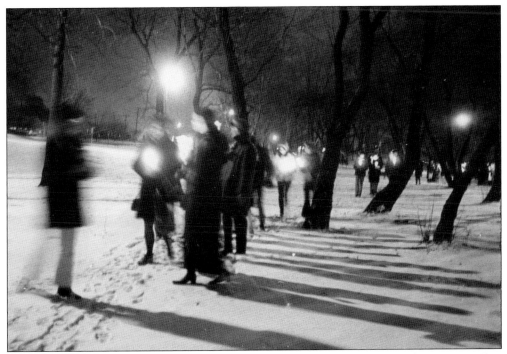

This 1969 candlelight protest of the escalating death toll of U.S. troops in the Vietnam War has been revived by the Women in Black since 2003. The group holds silent protests, often in downtown Royal Oak, to call an end to war in Iraq and Afghanistan.

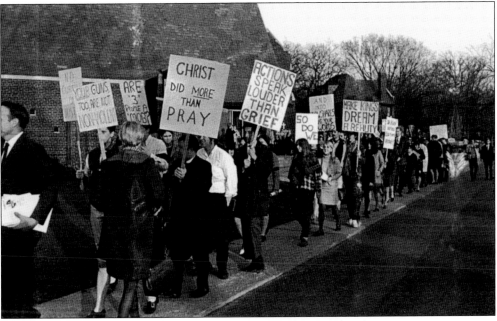

Civil rights leader Martin Luther King was assassinated in April 1968, prompting a protest at Woodward Avenue and Eleven Mile Road at St. John's Episcopal Church. Soon after these protests, Joan Baez came to sing at the Central Methodist Church in Detroit, leading a rousing, integrated chorus of the spiritual song, "We Shall Overcome."

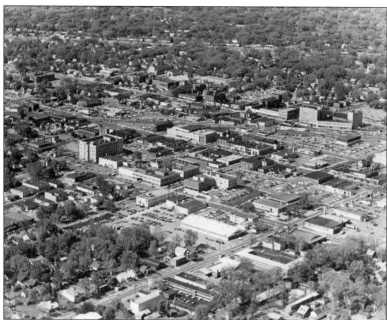

An aerial view of Royal Oak in 1968, at the height of the city's population boom, depicts a healthy blend of commerce, spiritual and residential, and a great number of trees that helped inspire people to set down roots in this community.

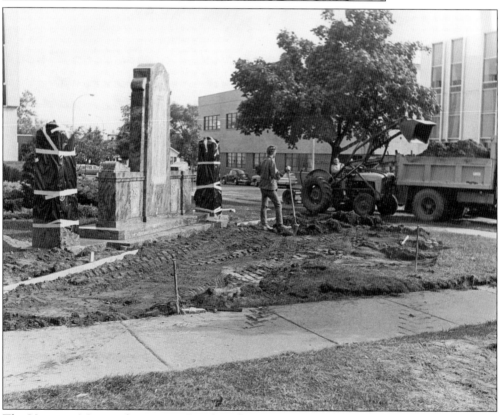

The Veterans Memorial statue is placed in the civic center complex. The heavy granite and marble monument has moved several times to accommodate landscape changes, but Veterans Day remains an annual holiday celebrated by men and women in uniform and well attended.

The Susie Q restaurant served famous "chicken-n-chips" and "fish-n-chips" for under $4, making this a popular stop for families by day and young motorists cruising Woodward Avenue by night. For more information, see *Cruisin' the Original Woodward Avenue*, an Arcadia Publishing book by Anthony Ambrogio and Sharon Luckerman. (Courtesy of Larry Payne.)

LATE·HOUR·DINING AT THE SUSIE·Q

★ SORRY, WE CANNOT BE RESPONSIBLE FOR LOST OR EXCHANGED ARTICLES ★

APPETIZERS & SOUPS

200 SOUP OF THE DAY, Cup 1.10 Bowl 1.20	304 CHILLED FRUIT CUP	.95
300 FRESH SHRIMP COCKTAIL. Tender and tasty Shrimp, arranged on fresh crisp lettuce and Tossed Salad Greens. Served with our special Hot Sauce and Club Crackers 3.65	303/4 CHILLED TOMATO JUICE, 4-oz.	.75
	303/8 CHILLED TOMATO JUICE, 8-oz.	.95

ENTREES
For Those Who Prefer to Order a la Carte

HF-1 HOUSE FEATURE: "S-Q" SUPREME ROAST BEEF au-Jus
Choice of Mashed or French Fried Potatoes. LARGE ROLL AND BUTTER INCLUDED 3.90

HF-2 Same as above, with "DIAMOND JIM" BRADY SERVING OF BEEF.. 5.99

1 BROILED - WESTERN STYLE CHOPPED BEEF STEAK - *KING SIZE*
Tasty and juicy, topped with French Fried Onion Rings, Choice of Mashed or French Fried Potatoes 6.35

2 WESTERN STYLE CHOPPED BEEF STEAK - *FEATURE SIZE*
A LOT OF GOOD EATING! Same TOP QUALITY WESTERN BEEF as used for [1] skillfully broiled to retain all of its juiciness and fine flavor, topped with French Fried Onion Rings, Choice of Mashed or French Fried Potatoes, LARGE ROLL & BUTTER INCLUDED 5.75

3 "U.S.-CHOICE" SIRLOIN CLUB STEAK
A heavy cut of best and properly aged WESTERN STEER STEAK, skillfully broiled to your order (Please see Steak Chart), topped with French Fried Onion Rings, choice of Mashed or French Fried Potatoes. 8.50

4 FAMOUS SUSIE-Q "CHICK-N-CHIPS"
½-Young and Tender Fry-Chick, Choice of Mashed or French Fried Potatoes. 3.99

5 "SESAME-CRUNCH" CHICKEN, "S-Q" STYLE
Disjointed ½-Young Fryer (3-Pieces), prepared for your eating enjoyment from an exclusive "S-Q" cooking recipe, served with Mashed or French Fried Potatoes. 3.99

6 2-pcs. LOBSTER TAIL – "HOUSE SPECIAL"
Strictly a "S-Q" Food Specialty! Many Thousands of our customers said that it's the Best Lobster they ever ate. Served with Drawn Butter and Lemon Wedge. Choice of Mashed or French Fried Potatoes. 11.55

7 3-pcs. LOBSTER TAIL "SUPREME," with CHEESE GLACE
Another typical "S-Q" Exclusive! Delicate in texture and of exquisite flavor. Served with Drawn Butter and Lemon Wedge. Choice of Mashed or French Fried Potatoes. 14.55

8 FAMOUS SUSIE-Q FISH & CHIPS TAKE OUT ORDERS 3.10
Young Ocean Scrod fried to perfection in our most modern and immaculately clean stainless steel equipment. Served with French Fried or Mashed Potatoes. We have sold many millions of servings of this delicious and wholesome Sea Food. 3.35

9 ASSORTED SEAFOOD PLATTER
A variety of "S-Q" Choicest Deep Sea Food Delicacies, freshly cooked to your order: Lobster, Fish, Shrimp, Oysters and Scallops. Served with Mashed or French Fried Potatoes, Tartar Sauce, Drawn Butter and Lemon Wedge. A truly Wonderful meal for the Epicure. 13.55

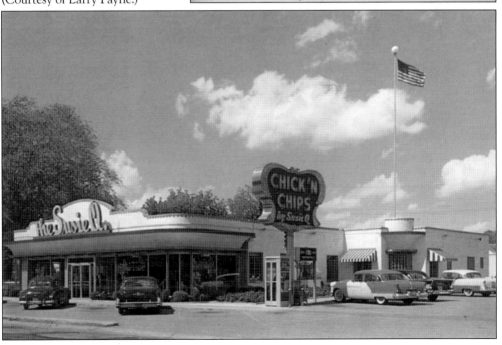

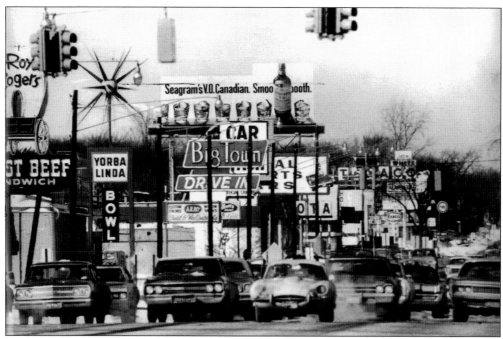

The epicenter of teenage street action in the 1960s was Thirteen Mile Road and Woodward Avenue. People gathered at the Northwood Plaza to compare the sizes of their engines. Fraternity and sorority types hung at Hobo's (then Roy Rogers Roast Beef and now Starbucks), and the rebels loitered at Maverick's (now Art Van's). Fights broke out periodically. When people tired of driving in circles, they visited the Yorba Linda Bowl for a game. The site is now a urology clinic. (Courtesy of Larry Payne.)

Maverick's started in the 1960s as a drive-in, becoming an upscale Chuck Muer restaurant in the 1980s, offering great food around a giant fireplace. The facility was torn down in the 1990s to make way for a stylish Art Van furniture store with inside parking. (Courtesy of Larry Payne.)

Nine

BENDING WITH CHANGE
1970s AND 1980s

If the mighty trees of Royal Oak survived savage winds by bending with the storms, the city fathers who took population increases and unlimited growth for granted faced a grim reality check in the 1970s and 1980s.

The developers of shopping malls sought to displace downtowns as the place where people bought dry goods. J. L. Hudson invested $20 million in building Northland Center in the 1950s, but a bigger threat to the vitality of downtown came in 1965, when Sears opened a store in the 1.5-million-square-foot Oakland Mall, just over the edge of Royal Oak in Troy.

That same year, Montgomery Ward's moved its store to Universal City Mall in Warren, creating a gaping hole in the downtown Royal Oak landscape and its tax base. The downtown S. S. Kresge store closed, and a brand new Kmart store opened in a nearby Clawson shopping plaza.

The city fathers brought the Southfield-based community planning consultants, Vilican-Leman and Associates, to help map out new plans for downtown that began to take root in storefront improvements and wide sidewalks. Among the civic heroes was John Hanna—who purchased the Washington Square Building in 1984 with his brothers Michael and Vance and close friend Don Tocco. Their $1 million investment and long-ranging vision helped to revive the city center. They tapped Keith Famie, who built a smart, 130-seat restaurant that soon became the epicenter of "cool," and Ron Rea, the architect of dining destinations.

That giant aerial ladder purchased in the 1960s came in handy in 1970 when firefighters battled to extinguish a downtown fire.

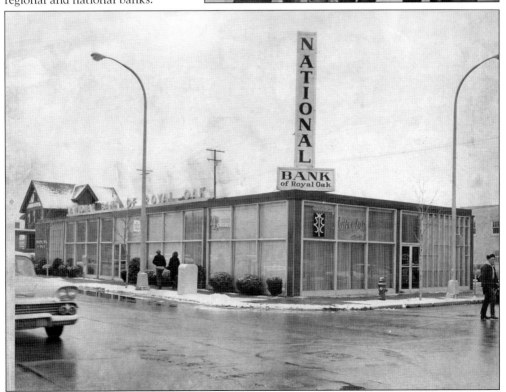

Boutique bankers in 1970 were bullish on Royal Oak's future, evidenced by the happy faces of a group of wealthy and influential businessmen. The bank occupied an entire block of Center between Third and Second Streets and offered state-of-the-art design, friendly tellers, and drive-up windows. But it could not compete for deposits with regional and national banks.

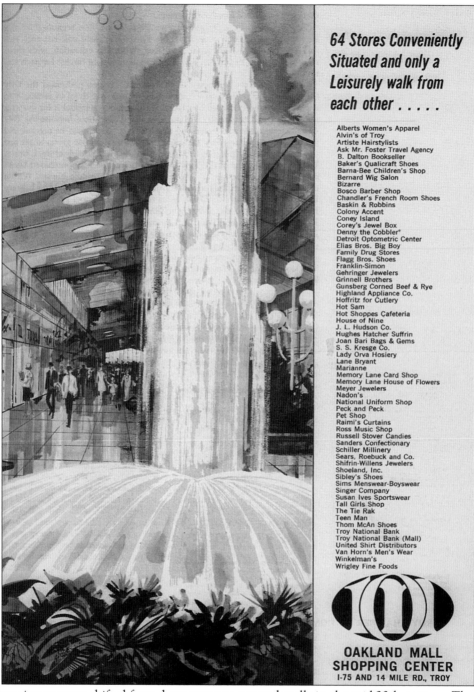

Shopping patterns shifted from downtowns to covered malls in the mid-20th century. There pedestrians enjoyed ample heat in the winter, ample air conditioning in the summer while strolling landscaped indoor gardens, full service department stores, and chain clothing stores. Oakland Mall, built in 1965 in the southernmost corner of Troy, grew to 1.5 million square feet of property housing 120 stores in the 1970s. It continues to grow with new plazas and out buildings flanking all four corners, a popular amenity for Royal Oakers. (Advertisement.)

Hudson's is more than a store. It's a phenomenon.

There's more to us than meets the eye. Hundreds of Hudsonians working above and below the selling floors. It's the only way we can live up to all the things you've grown to expect from Hudson's Northland, Pontiac and Oakland stores. In what you buy. In services you get. But then, Hudson's is more than a store. It's a phenomenon.

Built in the 1950s, the Northland Mall in Southfield enclosed its mall area in the 1970s, offering another formidable competitor to Royal Oak's downtown. The malls offered free parking and seasonal entertainment. Shoppers could complete their entire to-do list without a single raindrop fogging their eyeglasses. The venerable downtown suffered its first downturn since the Great Depression. (Advertisement.)

Tom Violante (center, holding fish) poses with employees at the meat counter. Tom and his wife, Janet, carved a regional reputation for porterhouse steaks and wild Alaskan salmon at their Holiday Market grocery store, started in 1953 and named after the popular movie *Roman Holiday*, starring Gregory Peck and Audrey Hepburn. Business surged with completion of the I-696 and Woodward interchange. In 1993 and 2007, the family expanded the store to create an ultra-gourmet destination. The market includes wine and flower shops, a cooking school, a full bakery and caterer, and fresh meats and cheeses. Ownership includes the second-generation Violantes—daughter Gina and her husband, Craig Mangold, and Tom Violante Jr.

Concern for the growing number of senior citizens came to the forefront in the early 1970s with construction of the 240-unit Royal Oak Manor at 606 South Williams Street, just north of downtown.

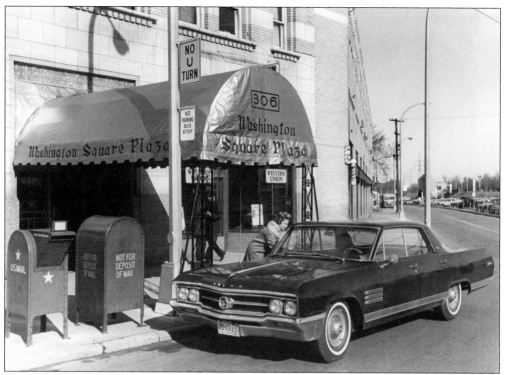

Washington Square Plaza gained a snappy canopy in the 1960s and a total renovation in the 1980s. Jack Hanna and Don Tocco of Chrysos Management and Development Company bought the property for $1 million in 1984. The team campaigned for months for a bank to finance the renovation, then moved dramatically forward with the first internet café, the first downtown Royal Oak office of the *Detroit Free Press*, and the Metro Music Café. The latter was a rock star bar that was inspired by the hottest trend of the decade—the Hard Rock Café—designed by leading interior designer Ron Rea of Birmingham.

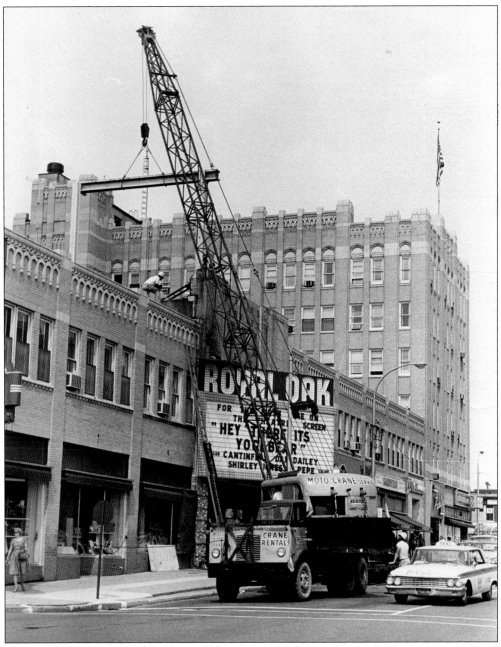

The Royal Oak Music Theatre thrives on concerts of all forms of music. In the 1960s, it received a new marquee, a remodeled lobby, and an adjustable movie screen. In the 1980s, it was remodeled for music and nightclub events. Setting a cultural rebound for Royal Oak, the Stagecrafters moved from Clawson to the Baldwin Theater and restored the 1928 jewel to modern splendor with 372 seats to enjoy musicals such as *Showboat*, *Kismet*, *Pippin*, and *Miss Saigon*. The first year in the new venue helped pump membership from 80 to 200 people, and it continues to grow with the help of organizations such as the Kresge Foundation, which nurtures cultural excellence among local artisans and organizations.

The newsmakers in town—the staff of the *Daily Tribune*—were a backdrop in 1980 for a made-for-television movie. Reporters, including coauthor John Schultz, were recruited as movie extras. *Word of Honor* starred Karl Mulden, Rue McClanahan, Ron Silver, and John Malkovich. (Courtesy of the John S. Schultz archives.)

The late Grant W. Howell, managing editor and editor of the *Daily Tribune* for 25 years until his retirement in 1978, made the suburban daily a force to be reckoned with in southeastern Michigan journalism. Howell was often a hard taskmaster. But a couple of generations of reporters looked back on the their experiences working for him as a superior education. Under Howell's leadership, the newspaper's reporting staff rose to a maximum of 17 in the late 1970s. Reporters and editors at the time were certain the newspaper could not be scooped in its own communities by the larger dailies in Detroit.

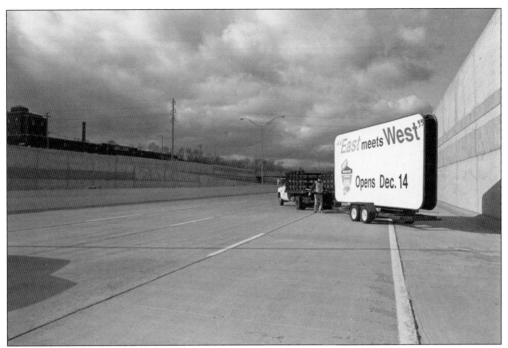

The last link of the I-696 expressway between Novi (I-275) on the west and St. Clair Shores (I-94) on the east opened on December 14, 1989, with much fanfare. The last 7.9-mile section between Royal Oak and Southfield took 30 years to build and bitter debates to overcome. (Courtesy of Michigan Department of Transportation archives.)

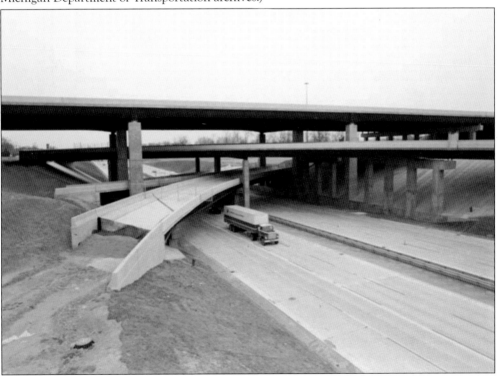

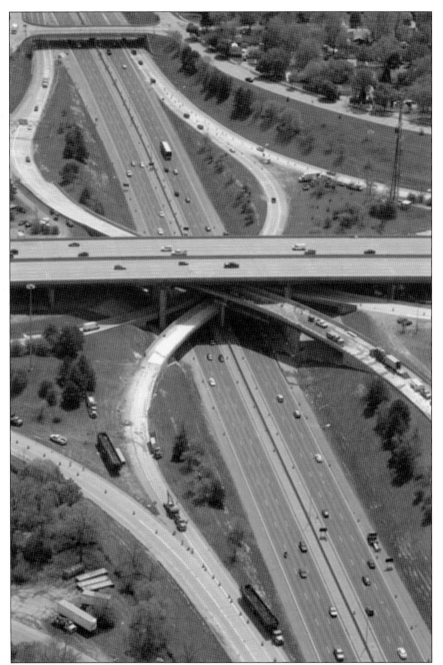

Here is a giant cloverleaf pattern of the I-75 and I-696 intersection. The eastern leg of I-696, along Eleven Mile Road, was the first section completed. According to John Michalak, retired reporter for the *Daily Tribune* who produced a series of front page stories on the highway construction in 1989, the cost of linking the east-west highway through south Oakland County broke down as $306 million for construction, $81 million to purchase the nearly 800 parcels in the 300-to-350-foot-wide right-of-way, and $49 million for engineering. Ninety percent of the project was federally funded, the balance from the state of Michigan. (Courtesy of Michigan Department of Transportation archives.)

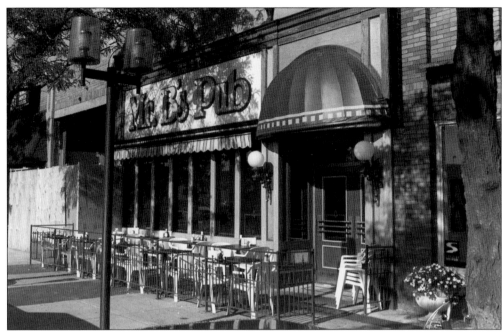

The freeway sped visitors from east and west and linked up with north and south commuters on I-75. Royal Oak had the perfect intersection for meet-ups. Quilting clubs, AIDS marches, networking meetings, lovers' interludes, and family dining took advantage of new restaurants close to the highway. Mr. B's Pub (above) opened in the 1980s and expanded in the 1990s. Owner Ralph Gustafson added Memphis Smoke and Monterrey Cantina to his Main Street restaurant portfolio. Each had a sidewalk café. Other poplar eateries followed, including Pronto! below on South Washington and B. D.'s Mongolian Barbecue on Main Street. (Above, courtesy of Ralph Gustafson; below, courtesy of Kreiger Photography.)

Ten

REINVENTING ITS ROOTS
1990 TO PRESENT

Wikipedia defines "walkability" as the extent to which the built environment is friendly to the presence of people living, shopping, visiting, enjoying, or spending time in an area. It comprises the land-use mix, the street connectivity, the residential density, and the amount of glass in windows and doors. Simply put, it feels good to walk around.

The Gen X clan wanted a respite from plazas, malls, and planned residential developments. They hungered for sidewalks, for vivid displays that pleased and delighted the eyes, and sent a buzz storming through their e-mail accounts.

In the 1990s, upstart entrepreneur Keith Howarth placed live models in his Main Street store to hawk untraditional jewelry and apparel at Noir Leather. Ron Rea, based on his success with the Washington Square Building and Monterrey Cantina, created even more playful interiors, including the dancing pigs at Memphis Smoke.

Memphis Smoke was one of three operations run by Ralph Gustafson and the Mr. B's Restaurant Group. Gustafson fought tooth and nail for liquor licenses, and the town was soon lubricated with new offerings, including the Town Tavern, Andiamo's, Vinotecca, and the Bastone. Affluent young adults bought lofts nearby so they could walk and play without moving their Mercedes or Mustangs. With their collective help and the vision of wise city fathers, Royal Oak arrived once again, as an intermodal town connected by bus, passenger train, taxicab, car, motorbike, and bicycle.

But change also brought turbulence. Nationwide attention was focused on multiple slayings at the Royal Oak Post Office and worldwide debate centered on ethical suicide advocate Dr. Jack Kevorkian, who rented a modest apartment dwelling at Third and Main Streets.

On November 14, 1991, suspended postal worker Thomas McIlvane killed five people, including himself, with a Ruger 10/22 rifle inside Royal Oak's post office where he had been employed. National attention to the tragedy gave way to the Internet euphemism for out-of-control-anger, "Going Postal." Surviving post office workers continue to hold a ceremony outside the building on each anniversary, remembering those who gave their lives to thwart the rampage. (Courtesy of the *Daily Tribune* archives.)

Two postal workers embrace each other on a chilly November 1991 afternoon, thankful to be alive after a discharged worker's shooting spree and aching for those who would never be alive to say "good morning" on another work day. (Courtesy of the *Daily Tribune* archives.)

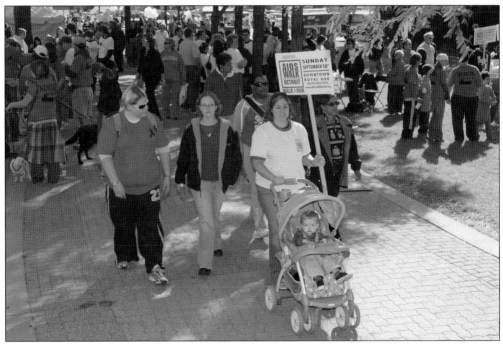

On a brighter note, Steppin' Out, a benefit for HIV/AIDS, began in 1991 as a September fund-raiser. Since then, it has raised over $2.8 million for more than 20 different agencies. Pictured here, the marchers walk along a pleasant autumnal route through Royal Oak.

Lively and playful storefronts helped create places to walk to and spaces to explore in downtown Royal Oak. In the early 1990s, Keith Howarth—owner of Noir Leather, an alternative clothing store—hired live models to perform shows in the window on Main Street. He began charging admission to wander the store. Howarth is shown below in front of his Third Street store in 1986. Eventually he moved the operation to a smaller site at the corner of Center and Fourth Streets and conducted more business via Internet and theater shows. (Left, photograph by Steve R. Nickerson; left and below, courtesy of Noir Leather.)

Dr. Jack Kevorkian, the Royal Oak–based physician, social activist, author, artist, and amateur musician, believed in the fundamental right of an individual to make end-of-life decisions. In the early 1990s, he lived above a florist shop on Main Street while parking his VW mercy van out back. He served several years in jail for assisting in a death that was recorded on video. His paintings are often displayed at the Ariana Gallery on Main Street. (Photograph courtesy of *Detroit Free Press*.)

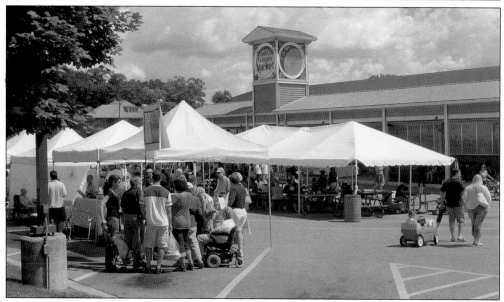

The Royal Oak Farmer's Market at Fourth and Troy Streets opened on October 14, 1925, as a cooperative venture. The present structure went up in spring 1927. Throughout the year, the booths ebb and flow with flowers, vegetables, and crafts, serenaded by live folk singers. On Sundays, it transforms into a giant flea market with ample parking for all. (Courtesy of Farmer's Market.)

The Royal Oak Historical Society celebrated its 70th anniversary in 2009, capping decades of painstaking record keeping of the town's earliest families, school photographs, clippings of famous individuals, and photographs of all sorts. Muriel Versagi (above), curator, moved its headquarters to the former Royal Oak Fire Station (below) just south of Chase's Corners—on Thirteen Mile Road and Crooks Road, the founding sector of the township. The photograph of the fire station is from the 1940s. (Above, photograph by Les Ward; below, courtesy of Royal Oak Historical Society.)

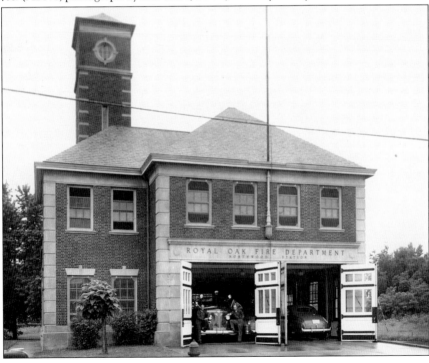

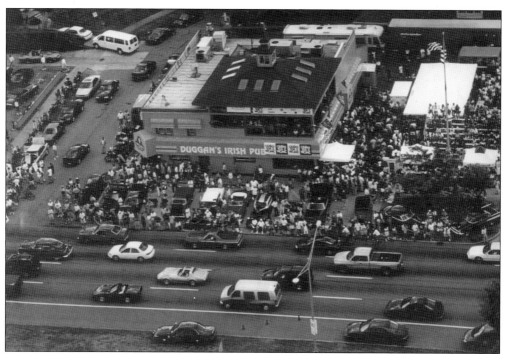

Larry Payne, longtime owner of Duggan's Irish Pub and other taverns around town, not only helped organize the Woodward Dream Cruise as an annual revelry to the muscle cars and American-made transportation, he preserved much of the archival materials of cruising lore. His family continues to run the restaurant with a panoramic view of Woodward Avenue. It serves a Big Chief burger made popular by the old Totem Pole in an atmosphere chocked full of memorabilia. Until his death in early 2009, Payne (front passenger seat) rode the cruising route on the third Saturday of August each year with friends in vintage convertibles. (Larry Payne archives.)

While muscle cars rule Woodward Avenue, bikers have their night once a week in summer in downtown Royal Oak and draw such an eclectic crowd, even the *Metro Times* and the Detroit Metropolitan Visitors and Convention Bureau joined forces to stage evenings for prospective businesses and individuals looking for a fun time in southeast Michigan. (Photograph by Rod Arroyo; courtesy of City Photos and Books, Inc.)

Gilda's Club, started to honor Gilda Radner, former *Saturday Night Live* comedian and native Detroiter, operates out of this historic house in northern Royal Oak on land once owned by Royal Oak pioneer David Williams on Rochester Road. The mission is to provide a welcoming community of free support for cancer victims, their friends, and families. There are 22 Gilda's Clubs across the nation. (Photograph by Sara Earl.)

Town Tavern is one of the newest bistros in Royal Oak, offering walls resplendent in town history and a large wine list to accompany its food offerings. (Courtesy of the Roberts Restaurant Group.)

The skyline of Royal Oak is forever changed with a surge in downtown loft development. It includes the Troy Street Lofts and the Center Street Lofts designed by Kevin Akey of AZD Architects in Birmingham. The combined developments helped inspire new retail and attract creative young residents who could park their Mercedes and Mustangs and do the town on foot. (Courtesy AZD Architects.)

The Cub Scouts wave flags along the annual Memorial Day parade on Main Street, a celebration as timeless as a Norman Rockwell painting and as modern as the Bean and Leaf Café in the background. The parade winds its way to the town cemeteries where speeches honor veterans and evoke past platitudes of U.S. presidents. (Courtesy of Brad Ziegler Photography.)

www.arcadiapublishing.com

Discover books about the town where you grew up, the cities where your friends and families live, the town where your parents met, or even that retirement spot you've been dreaming about. Our Web site provides history lovers with exclusive deals, advanced notification about new titles, e-mail alerts of author events, and much more.

Arcadia Publishing, the leading local history publisher in the United States, is committed to making history accessible and meaningful through publishing books that celebrate and preserve the heritage of America's people and places. Consistent with our mission to preserve history on a local level, this book was printed in South Carolina on American-made paper and manufactured entirely in the United States.

This book carries the accredited Forest Stewardship Council (FSC) label and is printed on 100 percent FSC-certified paper. Products carrying the FSC label are independently certified to assure consumers that they come from forests that are managed to meet the social, economic, and ecological needs of present and future generations.

FSC
Mixed Sources
Product group from well-managed
forests and other controlled sources

Cert no. SW-COC-001530
www.fsc.org
© 1996 Forest Stewardship Council

Find Your Place in History.